lovers

GREAT ROMANCES OF OUR TIME

THROUGH THE EYES OF LEGENDARY WRITERS

lovers

Edited by JOHN MILLER *and* AARON KENEDI

Introduction by DIANE ACKERMAN

A BULFINCH PRESS BOOK

LITTLE, BROWN AND COMPANY

BOSTON • NEW YORK • LONDON

First Edition
ISBN 0-8212-2612-6
Library of Congress Catalog Card Number 99-72454

Bulfinch Press is an imprint and trademark of Little, Brown and Company (Inc.)

Design: Big Fish, San Francisco
Research: Eleanor Reagh, Michelle Watts, Bessie Weiss

PRINTED IN ITALY

to my beautiful Alexandra

— AARON KENEDI

to my angel, K

— JOHN MILLER

contents

lovers

introduction

by DIANE ACKERMAN

WHO CAN SAY WHY two people become a couple, that small principality of mutual protection and regard? Plato claimed that our earliest ancestors were born hermaphroditic and so powerful they threatened the gods, who punished them by cleaving each being in half. From then on, Plato said, humans have longed for their other half, and when one finds it, love happens. That myth touches a familiar nerve. We long to feel whole, and we fantasize that we can complete ourselves by pairing up with someone else. At the heart of this longing, I believe, is a ghostlike memory somewhere deep in our being, of once being part of mother and staying semi-attached to her for quite a while after birth. That was bliss, indeed, for we were the center of the universe and all our needs mattered. Later in life, when people plunge into romantic love, each is the other's everything. Each obsesses about and feels completed by the other. Although love may feel like a roller coaster, case of malaria, or soap opera, it's probably an adult version of the attachment between mother and newborn. Evolution is economical; it rarely wastes a winning routine.

Some couples, like Ron and Nancy Reagan, are politely smitten with one another lifelong. Others, like Spencer Tracy and Katharine Hepburn, thrive on bickering, usually to the dismay of friends and the discontent of children. Some, like Dylan and Caitlin Thomas or Mary McCarthy and Edmund Wilson, embark on affairs tumultuous, tempestuous, and plainly destructive. Lovers don't always have similar personalities. In a sense Plato was right—we're often attracted to people with qualities we feel we lack. Sometimes couples even divide up personality traits: one does most of the self-interest, the other does most of the altruism; one handles most of the social niceties, the other handles most of the anger.

My partner of many years is novelist Paul West, and although we have separate careers, we sometimes are invited to give readings together. One evening at a midwestern university, a host introduced us to the audience as a couple "having absolutely nothing in common," and we laughed. Although we both prefer to read books brimming with lush style, sparkling imagination, and fresh ideas, our taste in other things varies. He likes the flamboyant. I like the intricately delicate. He patrols the darkest recesses of the night, working or watching tapes of beloved cricket matches, until 6:30 A.M., and then sleeping until noon or 1:00. I could drink in the daylight, and enjoy waking with the dawn and going to sleep at 10:00 P.M.

Our studies offer a good example of our essential natures. Paul's is a pack rat's heaven: a room thickly heaped with books, papers, research materials, and all the curious accumulata of a bustling novelist's life. One needs a guide dog and map to navigate it. There are only high windows and they're always covered, letting in no outside world, no light. "I don't need nature," he once told me. "I can create it." And he has, in roughly 20 works of astonishing fiction. On an old Smith Corona, he creates one lavish world after another and inhabits them with a cavalcade of fascinating people. He doesn't go out much. He hates wind, rain, snow, and weather in general. He's abundantly happy to talk with friends in letters and on the phone.

My study, on the other hand, is all windows. Letters and research materials are carefully filed in a series of cabinets I call my "portable universe." Photos of endangered animals I've worked with grace the walls, above memorabilia from distant lands. I relish nature, live in the world of nonfiction, go out biking every day, and schmooze a lot with friends. He can easily accommodate violence and evil into his imagination, work, and sensibility. I can't. I don't even like movies to end unhappily. I'm more homegrown American; he's more continental. Example: When he received a knighthood from the French government and thus became a Chevalier, I started calling him "Chevy" which is now one of his nicknames.

He has a different kind of memory from mine, an almost perfect recall—the past is a country he can homestead. I prefer Zen's idea of living mindfully in the present moment. I like to study nature and human nature. A kid of the Seventies, I'm more concerned with social issues and I feel dutybound to do volunteer work in the community. We differ in a hundred ways. When asked about the secret to our 29-year-long duet, we sometimes tease that we stay together for the sake of the children—each is the other's child. But the truth is that we're both wordsmiths, affectopaths, and extremely playful people. All the rest that solders us together is best left to a team of psychologists.

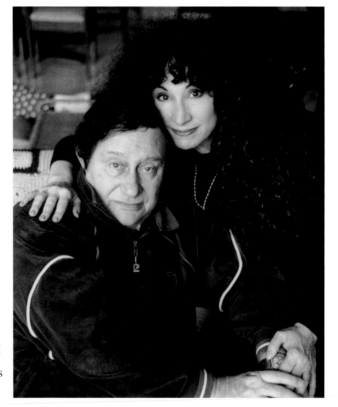

Paul and I have appeared briefly in each other's books over the years. But I kept asking him to write me "a kissy book" and at long last he did—an old-fashioned love story about our early years together. How eerily delightful it is to have someone else be the repository of your memories. How fascinating to see your youth reflected in someone else's eyes. Years ago, for a now-forgotten reason, he began calling me "Swan." In *Life with Swan* (Scribner, 1999), he includes many of the eccentric games, intimate dramas, and concerns of our life when I was a 20-year-old and he was in his late thirties. It's his version of me, not mine, and I respect his right to find me different than I find myself. This is a sleight of mind that nearly half of the following couples have also experienced. When artists live together, they inevitably show up in each other's work, they see themselves portrayed . . . in public. That was true for Gertrude Stein and Alice B. Toklas, for Frida Kahlo and Diego Rivera, for F. Scott and Zelda Fitzgerald, and so many others. In the case of acting couples, like Bogart and Bacall, there is the to-my-mind-even-stranger experience of watching their lover totally change personality and swoon over someone else on screen. Put two imaginative people together and romance is bound to flourish. Put two flint-like minds together and sparks are bound to fly. What makes a couple? Among those that follow, some are united by mutual interests, some were thrown together by work, some have personalities that fit like pieces of a jigsaw puzzle, and some seem to have absolutely nothing in common. All they share is love.

humphrey bogart
& lauren bacall

by LAUREN BACALL

I DON'T KNOW HOW IT HAPPENED—it was almost imperceptible. It was about three weeks into the picture—the end of the day—I had one more shot, was sitting at the dressing table in the portable dressing room combing my hair. Bogie came in to bid me good night. He was standing behind me—we were joking as usual—when suddenly he leaned over, put his hand under my chin, and kissed me. It was impulsive—he was a bit shy—no lunging wolf tactics. He took a worn package of matches out of his pocket and asked me to put my phone number on the back. I did. I don't know why I did, except it was kind of part of our game. Bogie was meticulous about not being too personal, was known for never fooling around with women at work or anywhere else. He was not that kind of man, and also he was married to a woman who was a notorious drinker and fighter. A tough lady who would hit you with an ashtray, lamp, anything, as soon as not.

At the end of the day of the phone number, I went home as usual to my routine: after eating something, I looked at my lines for the next day and got into bed. Around eleven o'clock the phone rang. It was Bogie. He'd had a few drinks, was away from his house, just wanted to see how I was. He called me Slim—I called him Steve, as in the movie. We joked back and forth—he finally said good night, he'd see me on the set. That was all, but from that moment on our relationship changed....

We'd exchange letters—I'd bring one down that he would read after I'd gone, and he'd give me one that I would read on the way home and twenty times after that. It was high adventure—very romantic, frustrating, and young. What any two people madly in love would do. Bogie's letters were all on the same themes: how much he loved me—how terrified he was of my being hurt—how he wanted to protect me—how wonderful of me to take that long drive to see him for so short a time.

> Baby, I do love you so dearly and I never, never want to hurt you or bring any unhappiness to you—I want you to have the loveliest life any mortal ever had. It's been so long, darling, since I've cared so deeply for anyone that I just don't know what to do or say. I can only say that I've searched my heart thoroughly these past two weeks and I know that I deeply adore you and I know that I've got to have you. We just must wait because at present nothing can be done that would not bring disaster to you....

[When we finally married] Bogie slipped the ring on my finger—it jammed before it reached the knuckle, the trembling didn't help, and then it finally reached its destination. As I glanced at Bogie, I saw tears streaming down his face—his "I do" was strong and clear, though. George [Hawkins] wisely kept my ring for Bogie on one of his own fingers through the ceremony, so it went very neatly onto Bogie's. As Judge Shettler said, "I now pronounce you man and wife," Bogie and I turned toward each other—he leaned to kiss me—I shyly turned my cheek—all those eyes watching made me very self-conscious. He said, "Hello, Baby." I hugged him and was reported to have said, "Oh, goody." Hard to believe, but maybe I did.

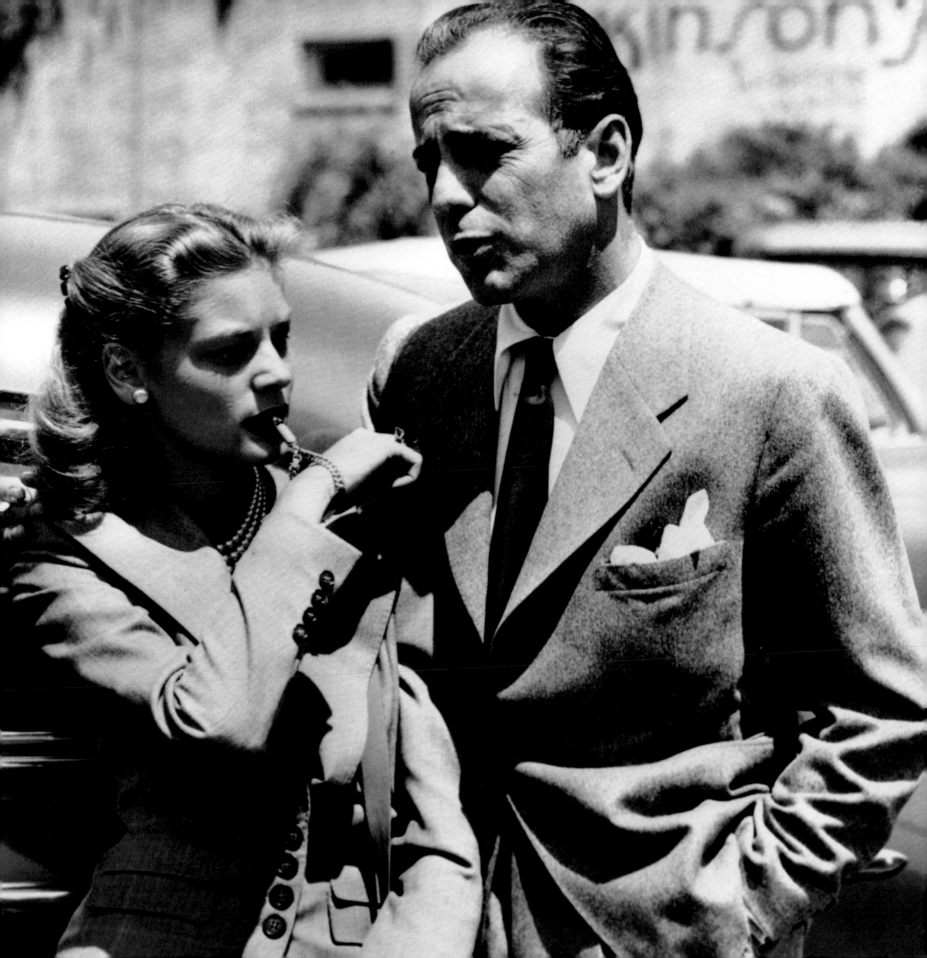

f. scott & zelda fitzgerald

by TOM GLIATTO

BOTH OF US ARE VERY SPLASHY vivid pictures, those kind with the details left out," Zelda Sayre wrote her fiancé, F. Scott Fitzgerald, two months before their wedding. "But I know our colors will blend...." And for the next decade they blended brilliantly as Scott and Zelda—perhaps the only literary couple known by their first names—burned their way through life on two continents until alcoholism and madness snuffed their partnership, but not their devotion. "Even in the darkest times," says Eleanor Lanahan, 48, one of their three grandchildren, "Scott still loved her and still believed that they were one person."

What ended in shadow began in the gaiety of a country-club dance in Montgomery, Ala., where Zelda, the 18-year-old town belle, met Francis Scott Key Fitzgerald, 22, a green-eyed lieutenant from nearby Camp Sheridan.

They married one week after the publication of *This Side of Paradise*, on April 3, 1920, in St. Patrick's Cathedral in New York City. *Paradise* quickly established Fitzgerald's reputation as a writer and as a spokesman for the Jazz Age, a name he had coined. Always at his side was Zelda, whom he called "the first American flapper." Together they looked "as though they had just stepped out of the sun," said writer Dorothy Parker.

Scott inscribed a book to Zelda, "my dearest, sweetest baboo," and they called themselves the Goofos. But alcohol soon became a problem—and remained one. He was a steady drinker, preferring straight gin because he thought it couldn't be smelled on his breath. Zelda often was drunk in public with her husband.

Scottie [their only child] maintained that she knew little of her parents' reckless lifestyle. "They were always very circumspect around me," she said. "I was unaware of all the drinking that was going on. I was very well taken care of, and I was never neglected." But it was a nomadic existence. Zelda "never liked a room without an open suitcase in it," says Lanahan. "They traveled light."

Seeking a creative outlet of her own, Zelda, at the late age of 27, took ballet lessons in Paris. For the next three years she often practiced eight hours a day. In 1930 she had her first breakdown—triggered, Scott felt, by her obsession with dance. She was hospitalized in Switzerland, where she was diagnosed as schizophrenic. Zelda spent most of her remaining years in mental institutions.

To help pay her medical bills, Scott defected to Hollywood as a screenwriter in 1937. There he took up with gossip columnist Sheilah Graham. Graham would later write a book about their romance, 1958's *Beloved Infidel*, and it was she who was with him in 1940 when he collapsed of a heart attack while eating a chocolate bar and reading the *Princeton Alumni Weekly*.

But though Scott died with another woman, he and Zelda had never lost their bond. Until her death, in a 1948 fire at a hospital in Asheville, N.C., she wrote "beautiful letters to Scottie about him," says Lanahan. "The tenderness is the point. That survived everything."

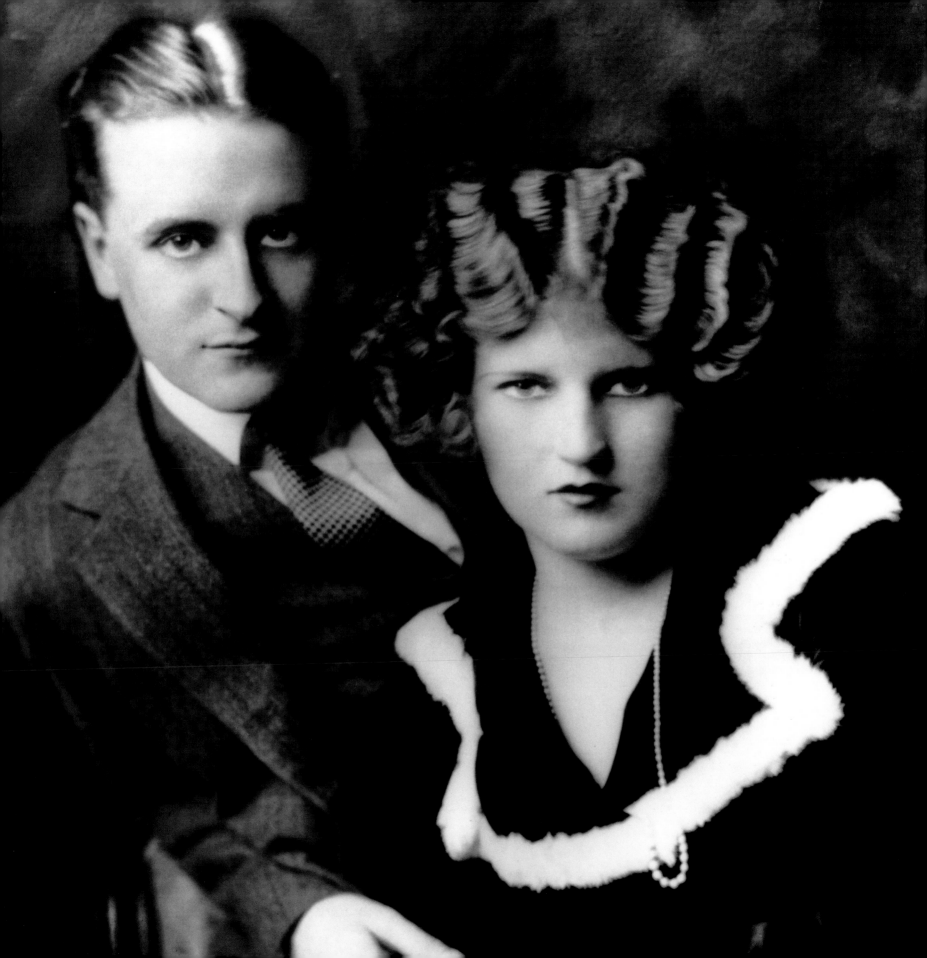

sam shepard & jessica lange

JOHN CONNOR

IT'S EASY TO BE ENVIOUS of Sam Shepard and Jessica Lange. The talented, beautiful and dynamic couple have won nearly every distinguished honor and award in the entertainment industry and—most impressively—often on their own terms; he the Pulitzer-Prize winning playwright, she the two-time Oscar winner. But as Lange herself told *Vanity Fair*, "it was never with the intention that we were going to run off, live together, have a family, do all these . . . *regular* . . . things. It was just this unbelievably passionate love affair. But then we just couldn't give it up."

Lange and Shepard fell in love on the set of the film *Country*, just as the rest of the world was falling in love with them. After *Tootsie*, Lange had become the heir apparent to the Blonde Icon mantle, and Shepard had just produced his critically acclaimed play *Fool for Love*. Soon the notoriously private couple began one of the most publicized off-screen romances in recent memory. The fact that both were still married and had children could not dampen the affair.

"It was a no-win situation," Lange told *Vanity Fair*. "He was married and I had a little year-old baby. And when we were together we were so wild—drinking, getting into fights, walking down the freeway trying to get away—I mean, just really wild stuff. I didn't want to keep going in that direction. So we quit talking. Then, through the works of some good friends, we got back in touch and that was it. He left his wife. I was in Iowa doing pre-production for *Country*, so he met me there, and we drove to New Mexico, and that's where we settled."

So, as J.T. Jeffries wrote in his 1988 biography of Lange "while Jessica Lange and Sam Shepard whiled away their time on the ranch in New Mexico, the rest of the country drooled. Shepard, it appeared, had met his match in Lange. He was clearly a man, if not a fool, in love." Jeffries details how *American Film* reporter Blanche McCrary Boyd interviewed him in New Mexico where Shepard made sure he was interviewed in the same restaurant he knew Lange would be. The reaction to Shepard's involvement with Lange brought an incredulous response from peers. It was really too much: "He's the best playwright in America," one friend told *Vanity Fair*'s John Heilprin. "He's a Pulitzer. He's good looking. He's a movie star. He lives with Jessica Lange. I hate him."

Still, as Lange told *Vanity Fair*'s Nancy Collins, she feels they had no choice. "Sam and I were so much in love, so wild about each other and being together. We were absolutely inseparable. We couldn't even go to the grocery store without each other," she says, breaking into a smile.

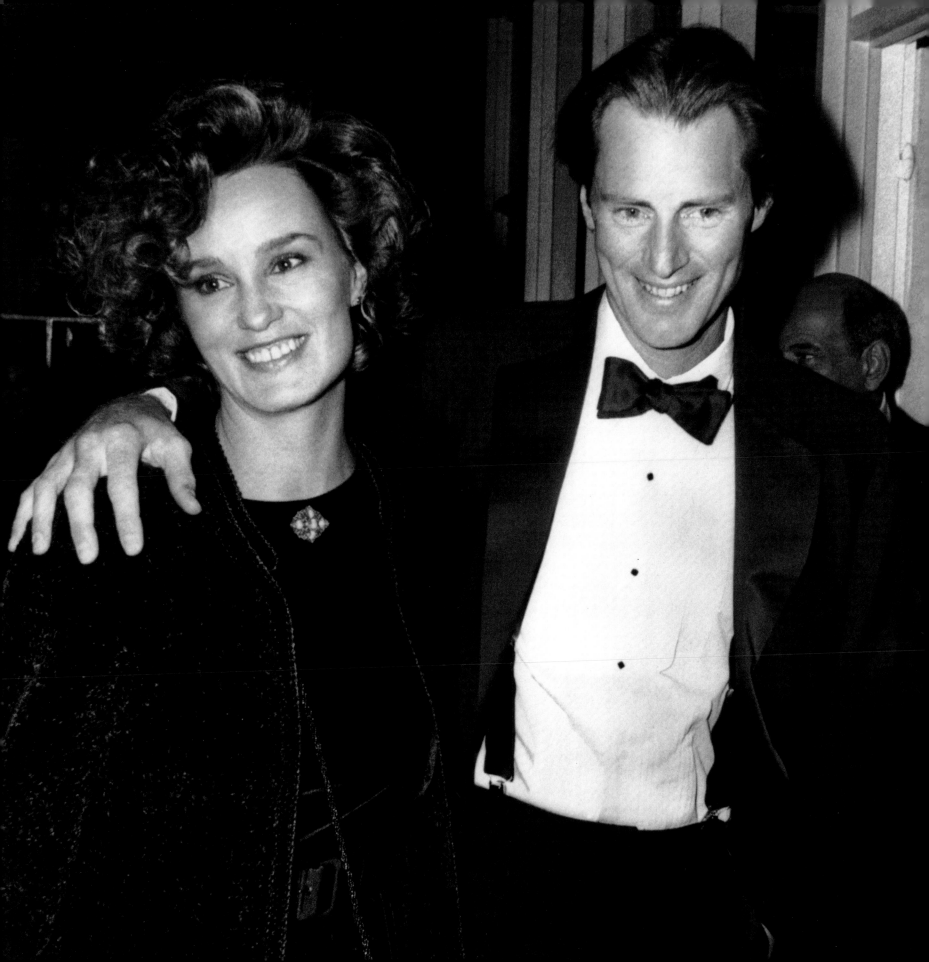

john kennedy &
jacqueline kennedy

CHRISTOPHER ANDERSEN

FROM THE VERY BEGINNING, theirs was destined to be one of the most celebrated unions of the twentieth century: he the handsome, charismatic young standard-bearer of one of America's most powerful families, she the darkly beautiful thoroughbred. By the time it ended with gunshots in Dallas, John Fitzgerald Kennedy and his wife, Jacqueline, were indisputably the First Couple of the World.

The way we would come to view them mirrored the disillusionment and growing cynicism of the age. By the 1980s, Camelot was dismantled brick by brick and the Kennedy myth irreparably shattered. Even those of us who vividly recall where we were and what we were doing the moment we heard the news of JFK's assassination have had our memories of the President and his First Lady virtually obliterated by the avalanche of scandalous revelations. Jack's womanizing ways became fodder for the tabloids, while his widow transmogrified into the larger-than-life Jacqueline Onassis, more a creature of legend than a flesh-and-blood woman, mother, wife.

Whatever powerful forces drew these two remarkable people together also propelled them to the summit of power and prestige. And these same forces enabled them to survive one soul-crushing personal crisis after another—until only one remained to bear the heaviest burden of all.

They were outlandishly rich, impossibly attractive, brilliant, elegant, youthful, *exciting*. Glamour and power and sex and money—not to mention the dreams and aspirations of a generation—were embodied in the forty-three-year-old President and his thirty-one-year-old wife. They seemed truly blessed by the gods, so it should have come as no surprise when their story took on the dimensions of a Greek tragedy.

Given all that Jack and Jackie Kennedy came to symbolize, the tangled nature of their relationship is worth exploring—now more than ever. For this, the saga of their time together, remains one thing above all else: a great American love story.

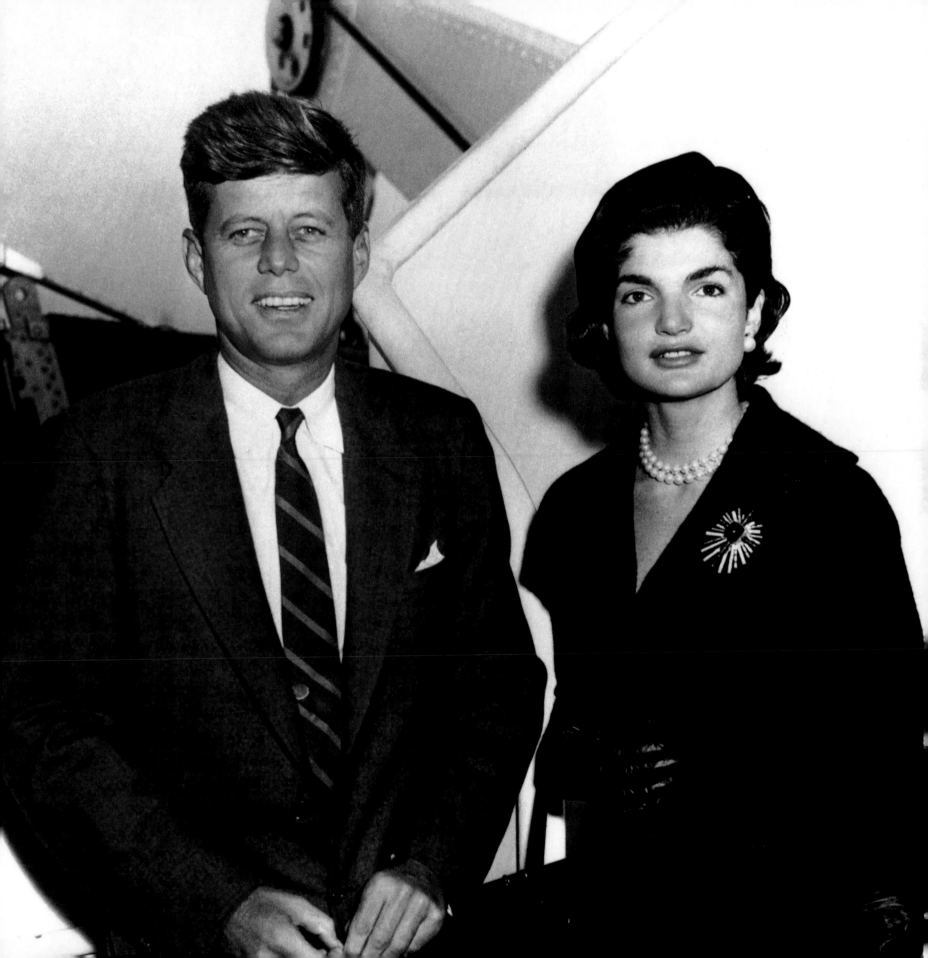

diego rivera & frida kahlo

by MARTHA ZAMORA

WHEN I WAS SEVENTEEN, Diego began to fall in love with me," Frida once explained to a journalist (subtracting three years from her age). "My father didn't like him because he was a Communist and because they said he looked like a fat, fat Breughel. They said it was like an elephant marrying a dove. Nevertheless, I arranged everything in the Coyoacán town hall for us to be married on the twenty-first of August, 1929." To a friend, Frida said, "I have suffered two serious accidents in my life, one in which a streetcar ran over me.... The other accident is Diego."

Many were struck by the incongruity of the petite, young Frida marrying the overweight, middle-aged artist. When her school friends heard about her marriage, they were shocked and surprised, considering it *una cosa monstruosa*, a hideous thing. But Frida was the last unmarried daughter of ill parents in sad financial straits. Her decision had pragmatic as well as romantic repercussions; in fact, Diego paid off the mortgage on her parents' home.

Certainly the striking pair's marriage, reported widely in the international press, offered Frida an opportunity to move not only in Mexican but leading European and American artistic and intellectual circles; she relished the contacts she made and the attention she received as the wife of a famous artist. But perhaps ultimately she was attracted by an attribute described by each of Diego's previous companions, his dynamism, by which he vitalized everything and everyone who came near him. He was possessed of a great and genuine warmth along with a capacity for charmingly tender gestures.

For all the strength of her personality, Frida felt insecure without Diego to praise her talents, cleverness, and beauty. When he withdrew from her, feelings of abandonment overwhelmed her. In July 1935, she fled to New York. There she resolved to accept her husband's wayward behavior; as she wrote Diego, she "loved him more than her own skin." According to her husband, she returned to him in Mexico "with slightly diminished pride, but not with diminished love." They established a pact that allowed frequent escapades for both, but with the mutual understanding that the affairs were something apart from their own special and intimate relationship.

Frida's love for Diego was still the major focus of her life. One of her diary entries gives some sense of her total devotion:

Diego...beginning / Diego...builder / Diego...my child / Diego...my sweetheart / Diego...painter / Diego...my lover / Diego...my husband / Diego...my friend / Diego...my mother / Diego...my father/ Diego...my son / Diego...I / Diego...universe / Diversity in unity / Why do I call him my Diego? / He never was and he never will be mine. / He belongs to himself.

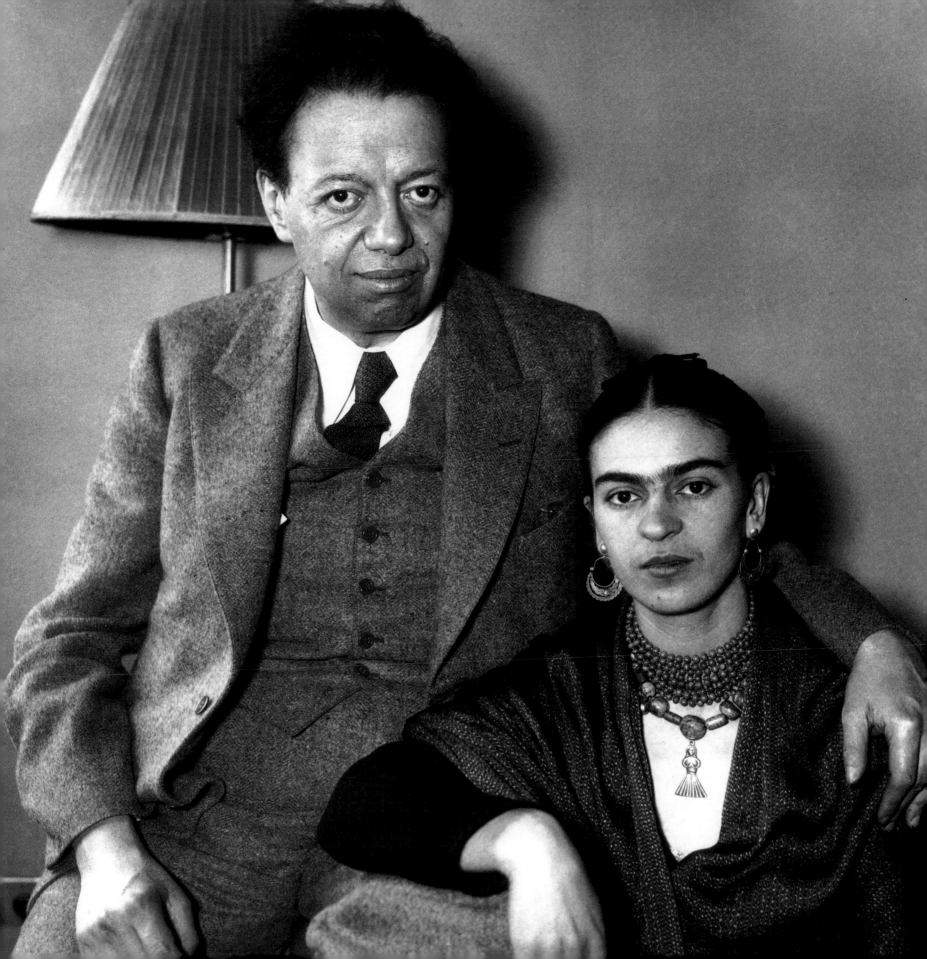

joe dimaggio &
marilyn monroe

by DONALD SPOTO

WHEN MARILYN MONROE met Joe DiMaggio in early 1952, she was twenty-five, he was thirty-seven. She was becoming the most famous star in Hollywood history. He was a national hero, recently retired from a stunning career in baseball. Both had been married once before.

Joe had wanted to meet Marilyn Monroe ever since he saw a news photo of her posing sexily in a short-skirted baseball outfit, trying to hit a ball.... Introduced at an Italian restaurant on Sunset Boulevard (after she had kept him waiting two hours), Joe found that she had never been to a baseball game and knew nothing about the sport. Joe had no interest in moviemaking. This mutual indifference alone might have scuttled any possibility of romance, but chemistry accomplished what conversation could not. Marilyn liked this quiet, tall, handsome man whose continental manners she took for a kind of courtly deference.... She found in Joe a strong, silent defender, a man willing to protect and love her without any deflection of attention. In late 1953, after two years of courtship, they decided to marry.... News of the Monroe-DiMaggio wedding filled headlines worldwide. It was the union of two of the most adored (and most poorly understood) Americans of the century.

But there were deep differences between Joe and Marilyn.... He could never accept that she wanted to continue working as an actress; she could not understand his shame at her frank enjoyment of her body and her pleasure in others taking pleasure in admiring it. [In 1956, Marilyn filed for divorce.] By 1961, after...the failure of two films and no prospects for the work that had always somehow sustained her despite its anxiety-provoking aspects, Marilyn was able to find consolation in nothing...she stayed at home in her darkened bedroom, playing sentimental records, subsisting on sleeping pills....

Marilyn's good friends Pat and Peter Lawford invited her to spend the last weekend of July 1962 with them.... She called Joe and asked him to meet her there. No one knew it would be the last weekend of her life. Marilyn had important things on her agenda for the weekend...[by Sunday] Joe headed to...tell his family what he and Marilyn had decided that weekend: Marilyn had agreed to remarry Joe....

Friday, August 3rd, she visited one of her doctors, Hyman Engelberg, who gave her a prescription for twenty-five Nembutal capsules [to] fight off the insomnia she dreaded.... By Sunday morning she was dead.

The body desired by millions belonged to no one. On Monday morning, August 6—the day her wedding dress was to be delivered—Marilyn's remains still lay unclaimed at the Los Angeles County morgue. And so, to no one's surprise, Joe DiMaggio stepped in to take care of the last details.... At the funeral, before the casket was closed, Joe bent over, weeping openly as he kissed Marilyn. "I love you, my darling," he said, placing a nosegay of pink roses in her hands. Henceforth, for twenty years, flowers would be delivered weekly from Joe to her burial place—just as he had promised.

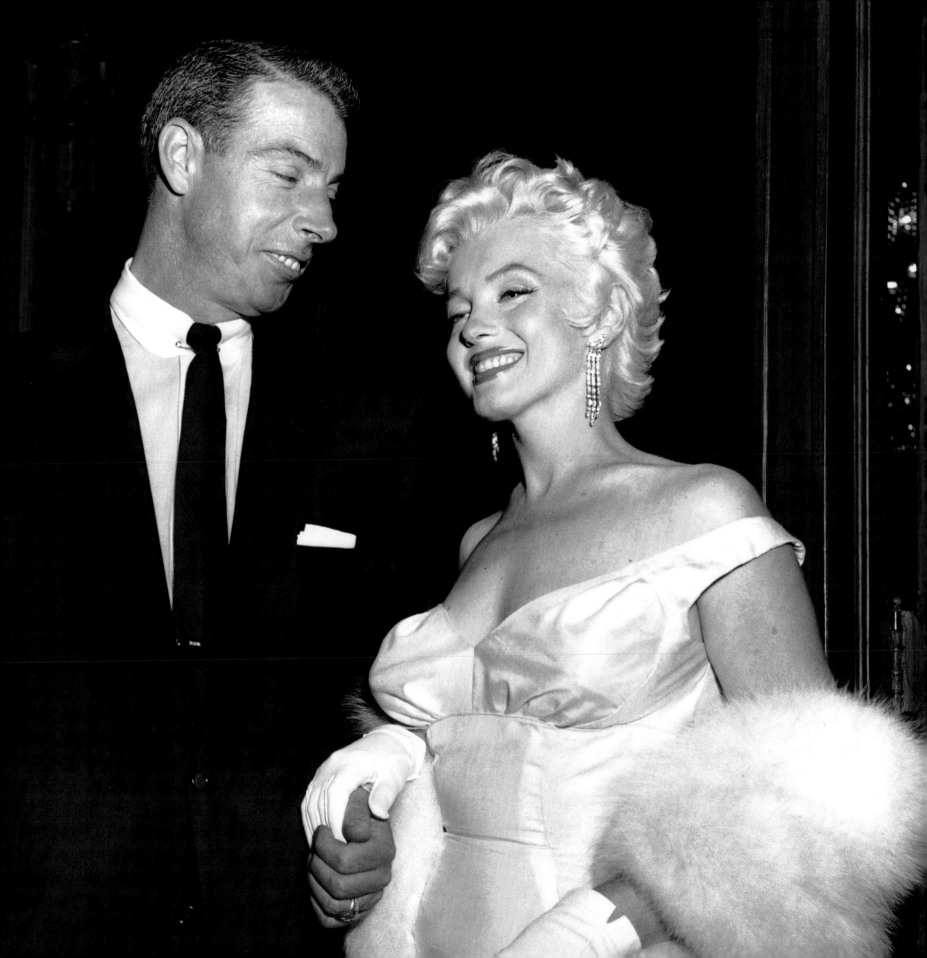

paul newman &
joanne woodward

by A.E. HOTCHNER

I FIRST MET PAUL in the spring of 1956 at a time when we were both very nervous. I was nervous because I had written my first television play, an adaptation of Ernest Hemingway's short story "The Battler…" After one of our rehearsals, Paul and I went to a nearby diner for lunch, and we were joined, at his invitation, by a most attractive young actress who had been on the Broadway stage with him in *Picnic*. She was, of course, Joanne Woodward. Sitting across from her, Paul went on at length about his doubts that he would be able to pull off this difficult character role. Joanne heard him out; then, smiling at him, she said softly, "You'll be fine." His worried face relaxed as he returned her smile. And, of course, when the program was aired, Paul was just "fine."

Two years later, they got married, and over the intervening 39 years that smiling look between them and that support for each other have reverberated innumerable times. When they perform together, they don't need words to communicate; they have their own code of transferences….

When they act together, theirs is a conspiracy of passion—passion for their craft, for their roles, for bringing the very best out of each other. In *Mr. & Mrs. Bridge,* there is a scene that takes place in a restaurant during a storm of hurricane proportions. While all the other diners hurry out of the dining room for cover, Mr. Bridge stolidly insists on continuing his dinner as everything crashes around them. Mrs. Bridge is apprehensive but obliging; he is committed to not knuckling under. The flow between them is delicate, finely tuned, personifying all the drama of the Bridges' inhibited lives.

It has been said that marriage is that relationship between man and woman in which the independence is equal, the dependence is mutual and the obligation is reciprocal. Joanne and Paul personify that definition. They rigorously respect one another's territory; if one of them is invited as a couple to participate in an event, neither will accept on behalf of the other. Their careers often require them to be apart, but they communicate daily so that even when they are separate, they share whatever problems or events are transpiring in each other's lives.

In recent years, the Newmans have devoted their talents to the food business. With some of the profits (all of which are given to charity), a camp was erected in Connecticut in 1988 for children with cancer and other life-threatening diseases….

Last summer, while we were all in the back of the camp theater watching a group of children singing and dancing, I happened to look over to where Joanne and Paul were sitting. The smiles on their faces bespoke the empathy and love they have for these brave kids, and I realized that they bring to their everyday lives the same commitment that they bring to their performances. It is the same all-out commitment that they make to their own children and to the world around them.

john lennon &
yoko ono

by RAY COLEMAN

JUST BEFORE GOING TO AMERICA in 1971, John told me: "We'd like to be remembered as the Romeo and Juliet of the 1970s." Yoko continued: "When people get cynical about love, they should look at us and see that it is possible."

Their wedding was unconventional but romantic. Based in Paris for a couple of weeks in March 1969, they decided to charter a plane and marry in Gibraltar. The bride and groom wore white tennis shoes and their clothes were also white. Yoko wore a white linen mini-dress and coat, a huge-brimmed white hat that contrasted vividly with her flowing black hair and white socks. John had a white jacket and off-white corduroy trousers. The man who had been cast as the waspish Beatle, hard and cynical, was old-fashioned about his marriage. "We are two love birds," he said. "Intellectually we didn't believe in getting married. But one doesn't love someone just intellectually. For two people, marriage still has the edge over just living together." At the ceremony he stood before the registrar in the British Consulate office with one hand in his pocket and the other holding a cigarette. "Oh, that wasn't important at all," he answered when asked if it was irreverent. "The event was *ours*. If I can't stand and do what I like at my own wedding . . ."

The scorn that had been directed at Yoko vanished immediately. People suddenly realized that she was human after all. "I got so emotional at the wedding I broke down and John nearly did, too," she said. "This man, rabbiting on about 'Do you take this woman for your wife?'—it was a tremendous experience." Back in Paris after only a seventy-minute stay in Gibraltar, John and Yoko went to the Plaza Athénée Hotel. Yes, Yoko reflected, marriage was old-fashioned, but both of them definitely respected it as an institution. John said that from then on they would do everything together, as artists and as husband and wife. Yoko said she would certainly not be the traditional wife, if that meant bringing him his slippers.

There was never any let-up in their proclamation of love for each other: signs proclaiming "John loves Yoko" and "Yoko loves John" hung next to them in bed for seven days. And when Yoko told John her £3 10s. ($6) wedding ring was too large and was slipping off her finger, John drew a temporary one in ink on Yoko's finger while the real one went for shrinking. A solid streak of conformity, convention, tradition, and romanticism bound them together while the world had exactly the opposite impression of them.

charles & anne morrow lindbergh

by LAURA MUHA

JUST AFTER 10 P.M. on May 21, 1927, a small silver-nosed airplane circled the Eiffel Tower, then headed northeast over Paris. In the cockpit, the weary young pilot swept his flashlight over the instrument panel to check that the readings were normal. Then he fastened his seatbelt and descended toward Le Bourget Aerodrome, where, unbeknownst to him, 100,000 people awaited his arrival.... Charles Lindbergh, an obscure 25-year-old airmail pilot from Minnesota, had just become the first person to fly nonstop 3,600 miles across the Atlantic Ocean—solo, no less....

Photographers staked out the hotels where Lindbergh slept and the restaurants where he dined; reporters trailed him on the street. Even a casual sighting with a female invariably led to headlines.... After the announcement of Lindbergh's engagement to Anne Morrow, daughter of the U.S. ambassador to Mexico, scrutiny intensified. Reporters offered servants bribes for information about the couple, and photographers routinely pursued them in high-speed car chases. Lindbergh typically tried to shake them off. "One time, driving Anne in my Franklin, I had to drive through a lot, onto a lawn, and down a six-foot hill onto another street," Lindbergh reported later. "An old couple rocking on a porch nearby stared silently."

After he and Anne married in 1929—in a ceremony so secret that even the guests weren't told about it in advance—they honeymooned alone on a boat on Long Island Sound. But newspapers, desperate to photograph the newlyweds, offered rewards to anyone who could pinpoint their whereabouts. Within a couple of days, a press plane was buzzing the couple's boat; later, Lindbergh had to drag anchor to get away from reporters who spent hours circling the boat in a motorized launch, hoping to make the couple seasick enough to force them out of their cabin.

Although she was timid by nature, Anne—with Lindbergh's encouragement—learned to fly and served as her husband's copilot and navigator during a series of trips to survey commercial air routes over the North Atlantic. Her book about one of their expeditions, *North to the Orient*, was a bestseller and also remains in print. And in 1930, while seven months pregnant, Anne helped her husband break the transcontinental speed record, flying from Los Angeles to New York in just under 15 hours—three hours faster than the previous record.

There is little doubt that Anne also had a powerful influence on her husband's writing. Charles Lindbergh penned seven books, and Anne read every word before publication, often making suggestions as to his choice of words. He dedicated his 1953 Pulitzer Prize-winning book, *The Spirit of St. Louis*, to her, saying that she would "never know how much of this book she has written." At the same time, Anne's writing was influenced by her husband. "He was very, very supportive of her work, and he would not let us bother her [while she was working]," recalls the youngest of the couple's five children, Reeve Lindbergh. "He was as much her editor as anybody."

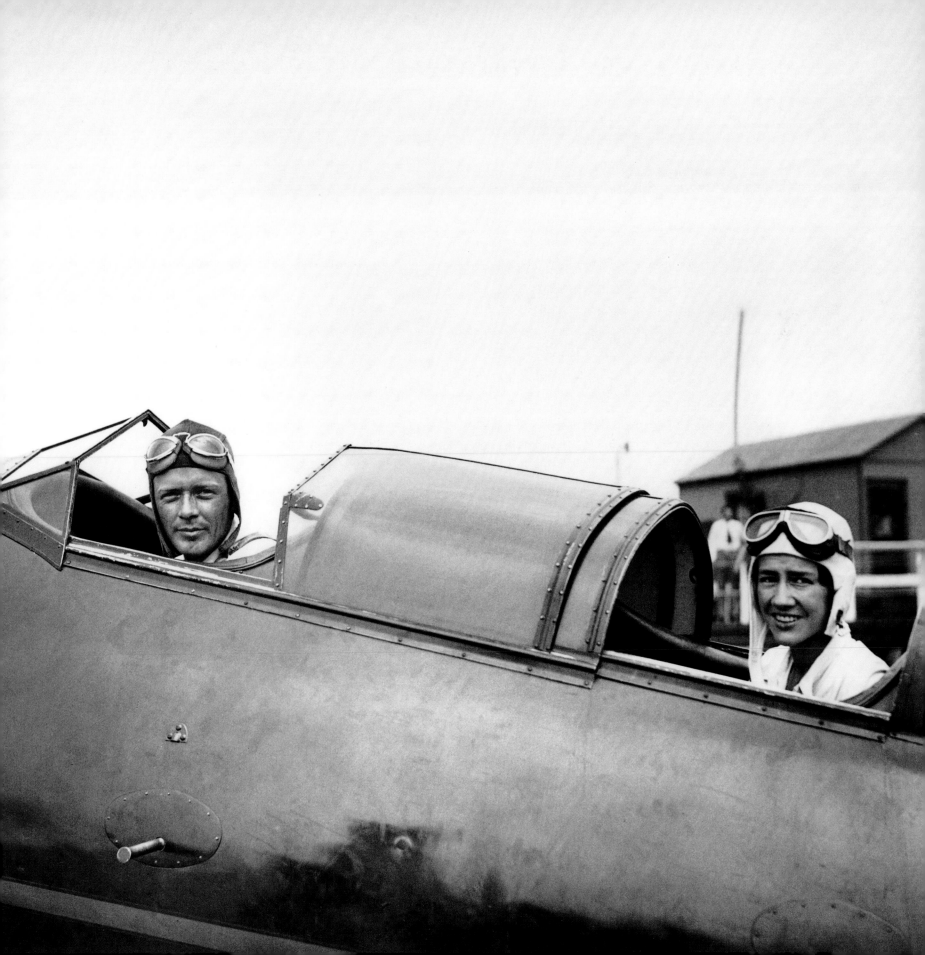

jackson pollock &
lee krasner

by DEBORAH SOLOMON

WHEN LEE KRASNER LEARNED in November 1941 that John Graham planned to include her in the show "American and French Paintings," she was ecstatic that her work would be hanging in the same room as that of her idols Picasso and Matisse. But she was also curious: Who was Jackson Pollock and why didn't she know him? The next day Lee walked over to his apartment. Jackson must have been surprised by this woman in his doorway, who told him boldly, "I'm Lee Krasner and we're in the same show." Lee Krasner was thirty-three years old, four years older than Pollock. She stood five feet five, with strong features and shiny auburn hair cut in a pageboy style. Lee took in Jackson's features and realized she had seen him once before. Five years earlier she had been dancing at a loft party sponsored by the WPA Artists' Union when Pollock had drunkenly cut in. "He stepped all over my feet," she once said. "He never did learn to dance."

Pollock led her to his studio. Four or five canvases were hanging on the wall. "To say that I flipped my lid would be an understatement," she said. "I was totally bowled over by what I saw."

She invited Pollock to visit her on Ninth Street the following week, and he showed up as scheduled, entering through a narrow hallway that doubled as a kitchen and sitting down in the apartment's one room. Lee asked him if he wanted some coffee. Yes, he said. She stood up and went to get her coat from the hall closet.

"Let's go," she said.

Pollock looked bewildered. "But you offered me coffee," he protested.

Lee had never used her gas stove, and she didn't even know if it worked. When she offered her friends coffee, she meant "Let's go to the corner drugstore."

They went out for coffee, once, twice, a dozen times, discovering mutual interests as if discovering the interests anew. He told her he was in Jungian analysis, and she was excited. "I was reading Jung on my own," she said, "so we had that as a common denominator." Naturally they also had art. He was Presbyterian and she was Jewish, but they worshipped the same god—Picasso.

"I was terribly drawn to Jackson," she said, "and I fell in love with him—physically, mentally—in every sense of the word. I had a conviction when I met Jackson that he had something important to say. When we began going together, my own work became irrelevant. He was the important thing."

A few months after they met, Pollock and Lee were walking along Varick Street one blustery winter afternoon when they ran into Clement Greenberg. . . . Greenberg said hello to Lee, then glanced at her new friend, waiting for an introduction. "This is Jackson Pollock," she announced. "He's going to be a great painter."

"Oh," Greenberg moaned to himself, "that's no way to size up a human being."

To Lee Krasner it was the only way.

richard burton & elizabeth taylor

by JANET CAWLEY

I HAVE BEEN INORDINATELY lucky all my life, but the greatest luck of all has been Elizabeth.... She is a wildly exciting lover-mistress, she is shy and witty, she is nobody's fool, she is a brilliant actress, beautiful beyond the dreams of pornography.... AND SHE LOVES ME!" —*Richard Burton to his diary, 1968.*

Whatever else they were, the 1960s were the banquet years, when overabundance was in overabundance. And by their conspicuous consumption of food and drink, jewels, hotel rooms and each other, Richard Burton and Elizabeth Taylor represented the age....

It was against a backdrop of excess that their momentous meeting took place, on the Rome set of the comically opulent and massively over-budget *Cleopatra.* Taylor told friends at first that Burton was a "duffer" who tried to flirt with a swinger's line: "Has anybody told you what a pretty girl you are?" With his friends, Burton disparaged Taylor as "Miss Tits." It was all a front, and it soon collapsed. During filming, the air between them was electric.

Burton and Taylor were married in Montreal in March 1964. In Boston, on their return from Canada, they got a taste of the crowd-and-media frenzy that would thereafter always surround them. "The police were literally knocked down by the crowd," recalls their former publicist John Springer. "When we finally got to the elevator, Elizabeth had chunks of her hair torn off, one of her earrings was gone, and her ear was bloody. The whole sleeve was torn off Richard's jacket."

The Age of Liz and Dick had begun. Between 1964 and 1972 they jointly earned $50 million. Burton bought Taylor a yacht and the 33.19-carat Krupp diamond, among many other sizable stones.

As they rolled across continents from picture to picture, their marriage also became a portable riot. At hotels, they would rent suites above and below their own so other guests wouldn't overhear their brawling.... His pet name for Elizabeth was *Twmpyn*, Welsh for Big Lump. When they quarreled, she was "the fat tart." Their marriage could not survive their drinking. On Independence Day 1974, they announced their separation. Burton told reporters, "You can't keep clapping a couple of dynamite sticks together without expecting them to blow up."

By 1975 she was eager to remarry. Their rematch lasted four months.... Their last fling was strictly theatrical, a tour in *Private Lives,* Noel Coward's comedy about squabbling but devoted divorcés. Then on Aug. 5, 1984, while asleep at home in Céligny, Switzerland, Burton suffered a fatal cerebral hemorrhage. This was the kind of separation that even the formidable Liz could not undo. At the news of Burton's death she became so hysterical that her then-fiancé, Mexican lawyer Victor Luna, ended their engagement.

[Burton] put it best before his death: "For some reason the world has always been amused by us two maniacs." Amused, horrified, delighted. And like them, always a little bit in love with the idea of Liz and Dick.

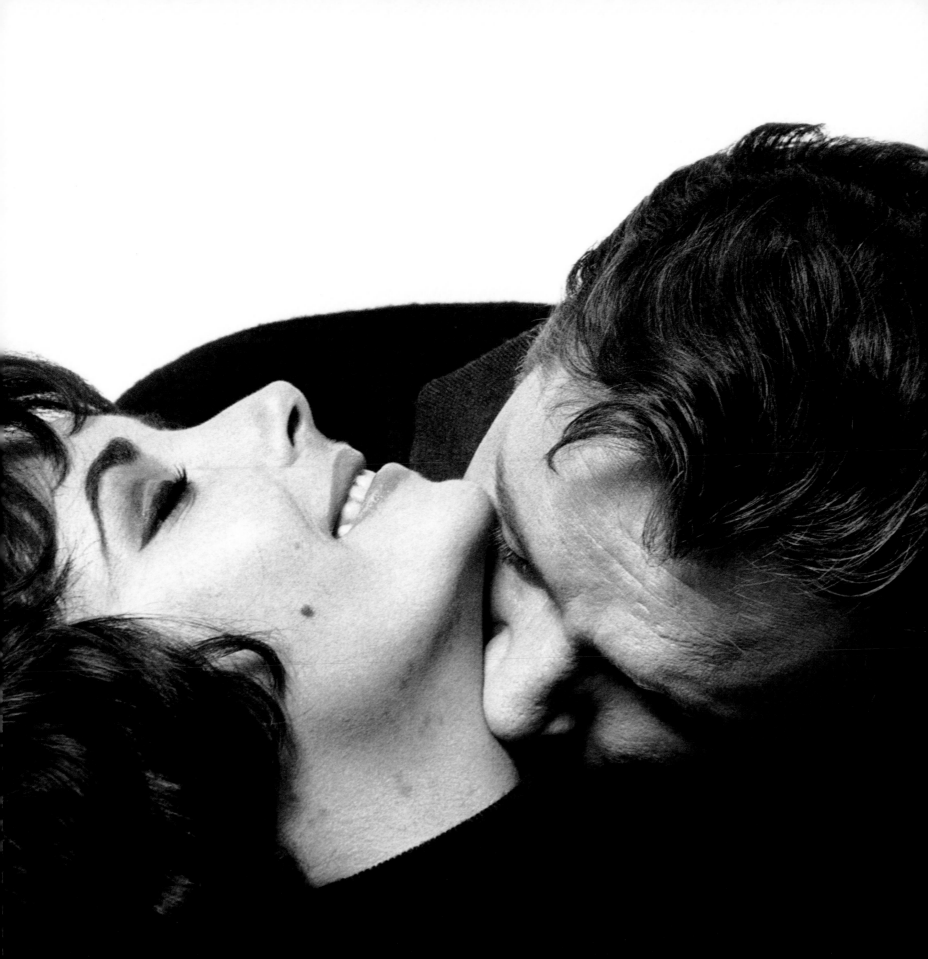

mick jagger &
jerry hall

by KAREN S. SCHNEIDER

MICK JAGGER WAS FIVE YEARS INTO HIS MARRIAGE with Bianca when he first met [Jerry] Hall—then a 21-year-old model—backstage at a Stones concert in London. She didn't seem to care that he was married; he didn't seem to care that she was engaged to his pal, Roxy Music singer Bryan Ferry, who had introduced them. "He pressed his knee next to mine, and I could feel the electricity," Hall wrote in her 1985 autobiography, *Jerry Hall's Tall Tales*. She knew she was not his first extramarital infatuation. "His life was like a railway station, with women constantly coming and going," she wrote. "No woman in her right mind would be willing to put up with that sort of hassle." Call her crazy. Hall canceled her wedding plans with Ferry. And Jagger left his wife—but made little pretense of maintaining monogamy. "Whenever I got home [from modeling jobs], I'd find things from other girls, such as earrings, next to our bed. It was so seedy," Hall wrote. "Mick's just a playboy. If this lasts a year, it's a miracle...."

Until recently, Hall's perseverance seemed to be paying off. She loved her routine at their Richmond home: growing organic vegetables in the garden, rollerblading with the children, taking them to church on Sunday and watching them frolic with their dad. "He gets down on the floor and plays silly games," she told *OK!* magazine in 1998. "I don't think he wants anyone to know about all the softy lullabies he sings to the babies. It might mess up his image." Together, husband and wife jogged in nearby parks, threw dinner parties and, like any other couple, fought now and then. Jagger, for instance, was annoyed that Hall insisted on keeping [son] Gabriel in bed with them for so long. And he was furious when Hall encouraged Elizabeth, now 14, to begin modeling last year. "He wants Elizabeth to concentrate on schoolwork," Hall said in the December issue of *Harpers & Queen*. "But I tell him, almost *every* schoolgirl wants to be a model."

Still, such clashes, friends say, were not a threat to the relationship. "Often they're furious," says Antony Price. "They blow their tops easily but forgive just as easily."

That, of course, was before *l'affaire* Morad broke. Those who know the couple are unsure how bitter the battle will be. Hall—whose modeling career has made her wealthy in her own right—reportedly signed a prenuptial agreement limiting her access to Jagger's fortune. And Price believes Jagger—whom ex-wife Bianca called a "penny-pinching Scrooge" after extracting a $1 million-plus settlement from him—will fight to keep his money out of Hall's hands. "The children are flesh and blood," says Price. "But the wife is someone you were in partnership with, and the partnership didn't work out." Still, if only for the sake of the children, he believes they will behave as they have during past troubles: "In a civilized way." Despite their differences, he says, "they are very close. They're friends." In the end, her close friendship couldn't combat his serial infidelity. "They all hope that it's going to be different," says Price of rock wives such as Hall. "But it almost never is."

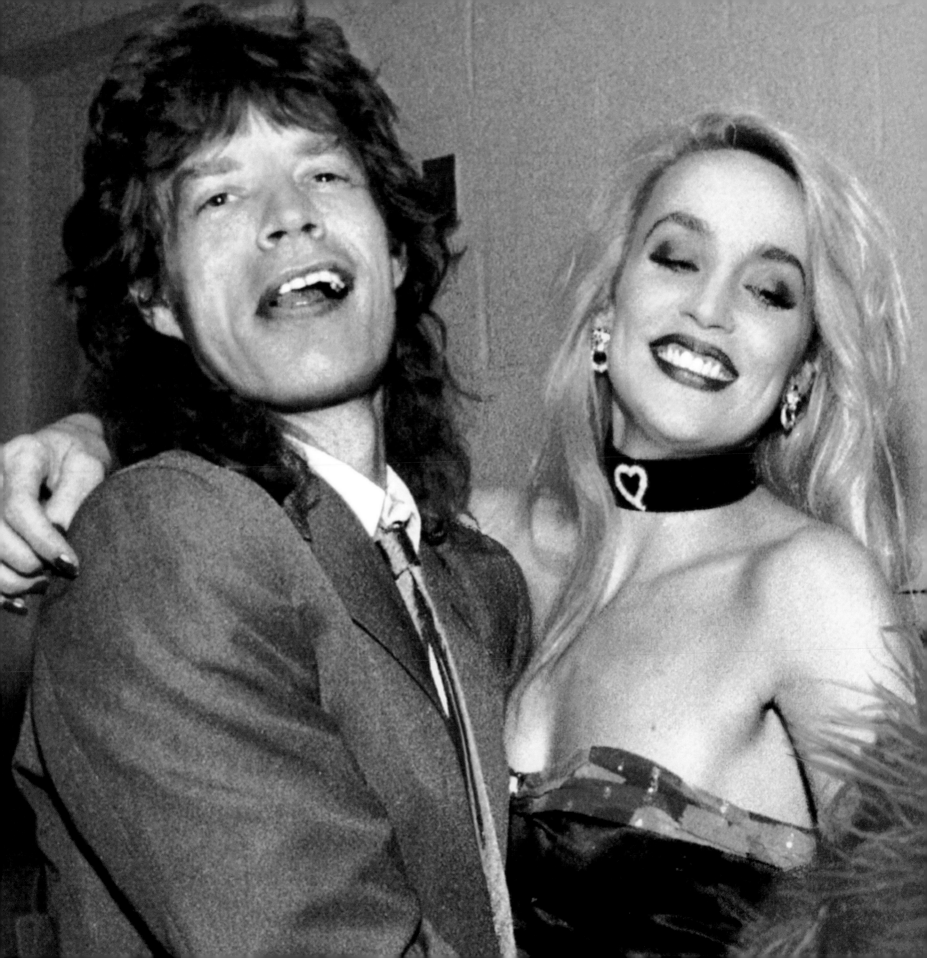

prince rainier & princess grace

JAMES SPADA

AN OBSERVER GIVEN TO SUPERSTITION might be forgiven for suspecting that some outside force was doing everything possible to prevent Grace Kelly's meeting Prince Rainier on May 6, 1955... As the car carrying Grace sped along the winding roads leading to the palace it was struck from behind by the car carrying the *Paris Match* photographers.

No one was hurt, damage was minimal, and the party arrived at the palace with minutes to spare. But Prince Rainier had not yet arrived from Beaulieu. An aide-de-camp suggested that everyone take a tour of the palace. As Grace walked through the grand apartments, private apartments, and museums, the photographers shot away, at one point capturing her gazing at the royal bed.

A guard announced that the Prince arrived, and in he walked. Grace saw before her a man younger than she had imagined him, and better-looking. As he extended his hand to her, she curtsied slightly. "How do you do?" the Prince said. "I am pleased to meet you. I am sorry I am so late." Nervous, charmed by the Prince's unexpectedly apologetic attitude, and surprised by how attractive she found him, Grace said nothing; she merely smiled back at him.... Rainier was surprised as well by this American movie star. Grace Kelly was unlike any other actress he'd ever met: refined, quiet, even shy. Her beauty could not be overlooked, but neither could her unusual dignity and quiet elegance. The Prince found his emotions enjoyably stirred. On the way back Grace seemed lost in thought. [A friend] interrupted her reverie to ask what she had thought of the Prince. "He is charming," she replied. "So very charming."

The strong chemistry between them at their half-hour meeting in Monaco, which had led Grace to sense that she fell in love with him that day, was cemented [on a] night in Philadelphia, and they both knew immediately that everything was going to work out between them.

"Everything was perfect," she explained later. "When I was with him, I was happy wherever we were, and I was happy with whatever we were doing. It was a kind of happiness...well, it wouldn't have mattered where we were or what we were doing, but I'd have been happy being there and doing it...I just can't explain it."

In Philadelphia, Grace and the Prince spent every possible moment together: they dined, strolled, visited Grace's friends, talked about themselves, opened up their hearts and souls to each other. In New York, Grace and the Prince did the town, and mention of their dates was made in the newspapers, but the significance of those dates could not have occurred to the reporters. On the 29th, Grace telephoned her mother to tell her that she and the Prince were very much in love and wanted to get married. Mrs. Kelly was ecstatic. "Imagine," she told a reporter later, "here I am a bricklayer's wife, and my daughter's marrying a prince!"

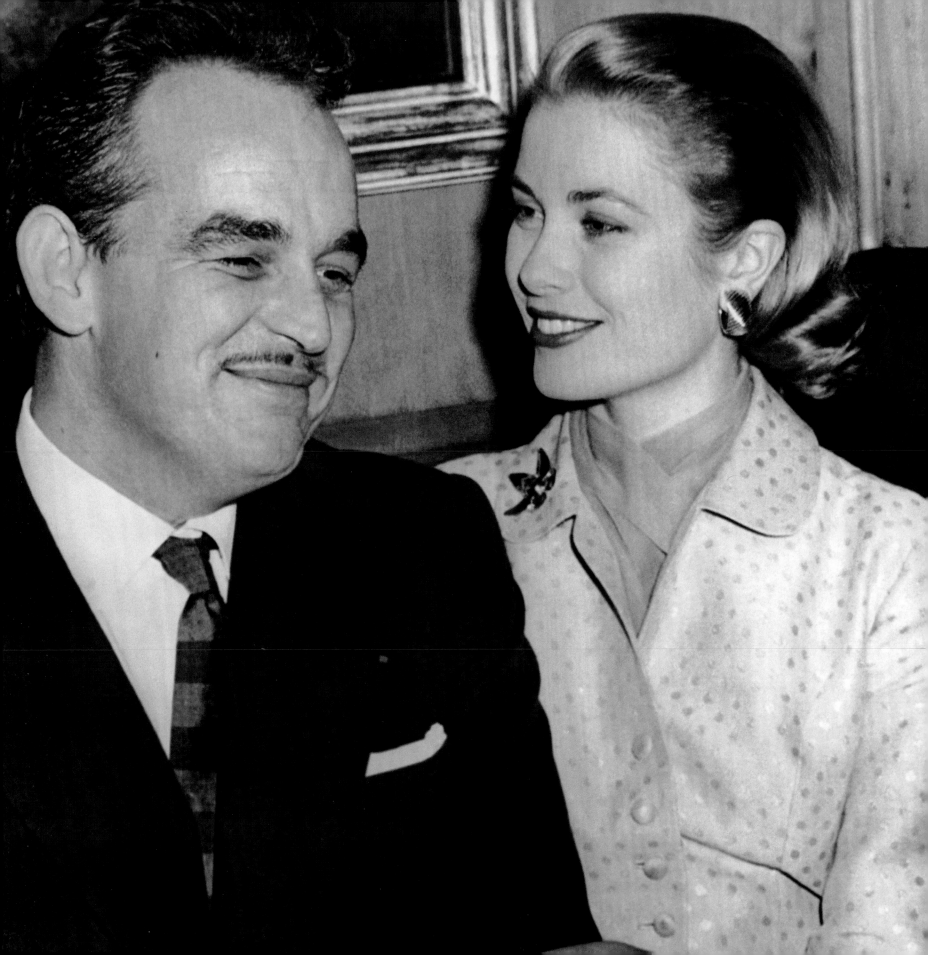

jimmy &
rosalynn carter

by JIMMY AND ROSALYNN CARTER

ROSALYNN: We have been with a number of married couples who look adoringly at each other and make such comments as "We've been together for thirty-eight years, and never had a cross word." Either they are stretching the truth or they are completely different from us. We've had some heated and extended arguments, but we've always been able to weather them because our basic love affair has not diminished in depth over the years. Interestingly, as we passed our fortieth anniversary, we realized that the arguments have become infrequent and less intense than in earlier years. Maybe we have exhausted most of the points of disagreement, or at least rounded off the rough edges of those that persist.

JIMMY: There was one aggravation that had persisted during our marriage. Perhaps because of my Navy training, punctuality has been almost an obsession. It is difficult for me to wait for someone who is late for an appointment, and even more painful if I cause others to wait. Even during the hurly-burly of political campaigns I rarely deviated from my schedule, and staff members had to go out of their way to ensure that these demands of mine were met. I was difficult on this issue and I know it.

Rosalynn has always been adequately punctual, except as measured by my perhaps unreasonable standards. All too frequently, a deviation of five minutes or less in our departure time would cause a bitter exchange, and we would arrive at church or a friend's house still angry with each other. For thirty-eight years, it had been the most persistent cause of dissension between us.

On August 18, 1984, I went into my study early in the morning to work on a speech and turned on the radio for the news. When I heard what the date was, I realized it was Rosalynn's birthday and I hadn't bought her a present. What could I do that would be special for her without a gift? I hurriedly wrote a note that was long overdue: "Happy Birthday! As proof of my love, I will never again make an unpleasant comment about tardiness." I signed it, and delivered it in an envelope, with a kiss. Now…years later, I am still keeping my promise and it has turned out to be one of the nicest birthday presents in our family's history—for Rosalynn and for me!

In a somewhat more modified form we have learned to address similar disagreements more directly instead of letting them fester. If direct conversation results in repetitions of arguments, we have learned the beneficial effects of backing off for a while. A good solution, we have found, is for one of us to describe the problem in writing. It is surprising how ridiculous some of the arguments seem when set down in black and white, and it is much easier to make the small concessions that can end the disagreement.

But what is life if not adjustment—to different times, to our changing circumstances, to shifting health habits as we educate ourselves, and to each other? Jimmy Townsend says it well: "Marriage teaches you loyalty, forbearance, self-restraint, meekness, and a great many other things you wouldn't need if you had stayed single."

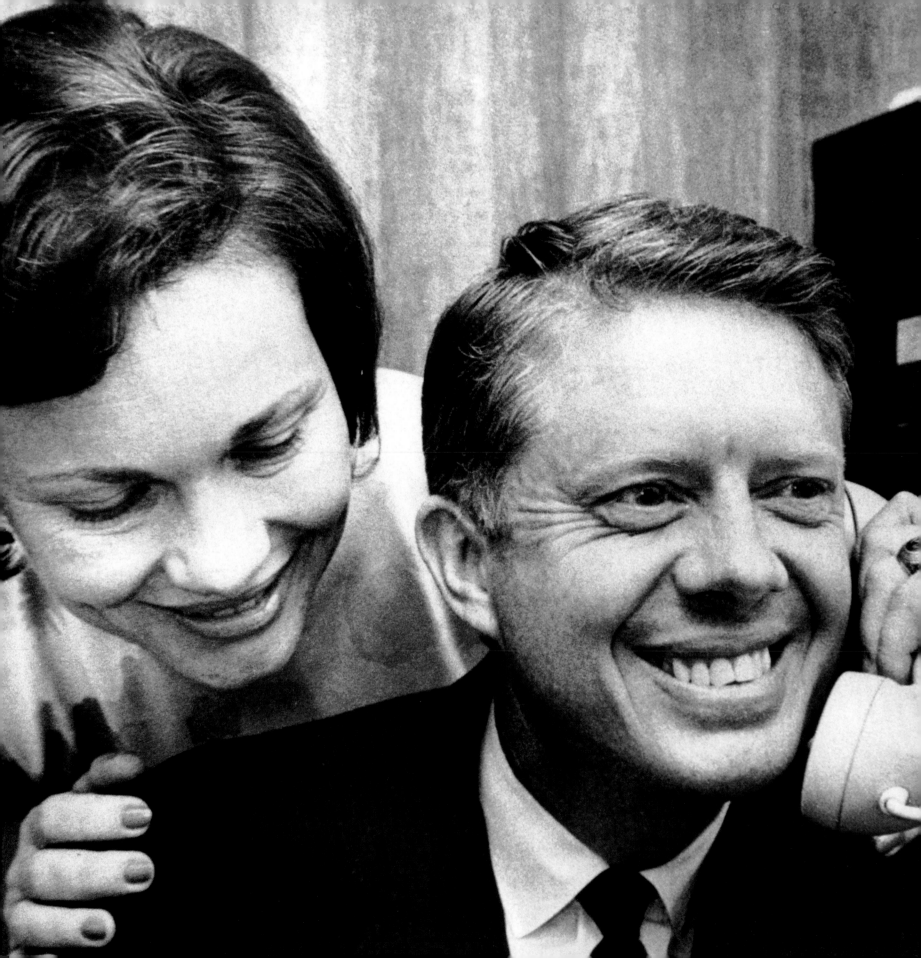

elvis & priscilla presley

by KIM HUBBARD

DID YOU SEE THE STRUCTURE of her face?" Corporal Elvis Presley, 24, asked guitarist Charlie Hodge on a 1959 evening in Bad Nauheim, Germany. "It's almost like everything I've looked for in a woman in my life." With 17 chart-topping songs and four hit movies to his credit, Presley had teenage girls around the globe clamoring to touch his blue-suede shoes. But what turned him into a teddy bear was 14-year-old Air Force brat Priscilla Beaulieu.

The ninth grader Elvis would soon call Cilla was struck by his bedroom-heavy eyes and insolent smile. "The first six months I spent with him were filled with tenderness and affection," she would write, "Blinded by love, I saw none of his faults or weaknesses. He was to become the passion of my life."

The passion—and madness—would continue for 18 years, until Elvis's death in 1977. From the beginning, though, the relationship had a pathological twist.... Late in the evening, Elvis would give Priscilla a signal, and she would quietly slip away to his bedroom, where a few minutes later he would join her. Sex was not on the menu, but cuddling next to her on his bed, Elvis unburdened himself. He was lonely: grieved over his mother's death, worried that his fans had forgotten him.

By January 1963, Priscilla and Elvis had convinced her parents that she should move to Memphis and finish high school there. Cilla moved into Graceland, where her schooling in the ways of Presley went into high gear. Inside those reclusive mansion walls, the tussles in the King's round bed became more elaborate. "Instead of consummating our love in the usual way, he began teaching me other means of pleasing him," Priscilla wrote. Cilla also learned how to play a part in Elvis's public life. "He taught me everything: how to dress, how to walk, how to return love—his way," she wrote.

Elvis handed over a 3-carat diamond ring in December 1966. The next May they were wed in Las Vegas. Afterward, he carried his 22-year-old bride across the threshold of their L.A. home singing "The Hawaiian Wedding Song."

Nine months after the ceremony, Priscilla gave birth to Lisa Marie. At first, Elvis was devoted to his daughter. But his feelings toward his wife had changed completely; their sex life was almost nonexistent. The King retreated into pills and spent more time touring. The marriage drifted. By 1976, Priscilla had washed the makeup from her eyes. "My life was his life," she said. "He had to be happy. My problems were secondary." When Priscilla asked for a divorce, "it killed him," says [songwriter Mae Boren] Axton. "It hurt his ego, and it hurt his heart."

The two never really said goodbye. "Even though there was a divorce," says Charlie Hodge, "they were like two high school kids. They still called each other and told each other everything they were going to do." When she finally heard about his death, Priscilla wrote, "I wanted to die."

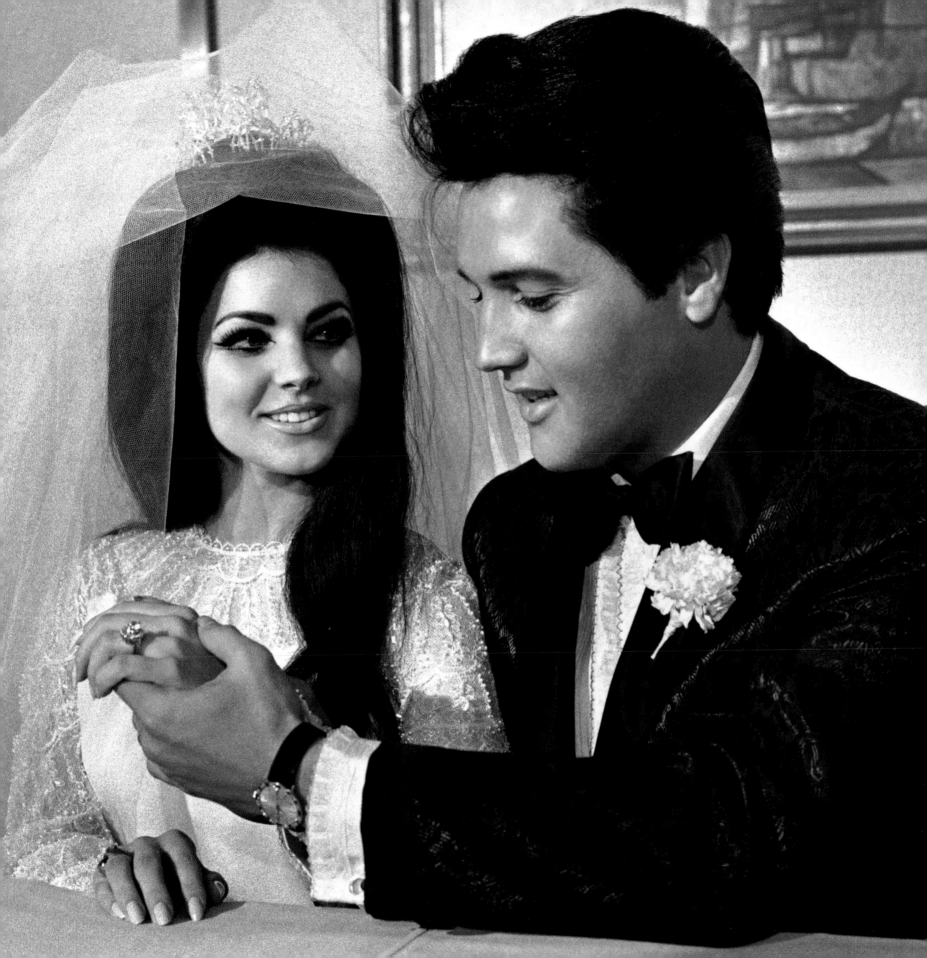

the duke & duchess of windsor

by WALTER ISAACSON

BRITONS AND MILLIONS OF OTHERS around the world were deeply moved when King Edward VIII spoke on the radio in 1936. The King's voice swelled with emotion as he made his declaration: "You must believe me when I tell you that I have found it impossible to carry the heavy burden of responsibility and discharge my duties as King as I would wish to do, without the help and support of the woman I love."

Besides being the climax of the romance of the century, that famous speech marked the beginning of the public reign of Mrs. Wallis Warfield Simpson, the dark, angular, citrus-tongued siren for whom Edward Albert Christian George Andrew Patrick David had set aside his crown. She married Ernest Simpson, a quiet, scholarly, American-born Briton, recently divorced, whose family had a prospering shipping firm. [In 1930 they] were introduced to King George V's slim, somewhat dandyish son David, the Prince of Wales. Early in 1936, David ascended the throne. Later in the summer, Mrs. Simpson accompanied the King on a Mediterranean cruise. Although the American press was avidly chronicling these goings-on, the English press, in deference to the royal family, printed not a word about the burgeoning romance, even after Mrs. Simpson made a scandalous marriage possible by applying for a divorce. The restraint soon ended. In November, even before Wallis Simpson's second divorce was final, the King informed Prime Minister Stanley Baldwin of his intention to marry her . . . and then abdicated, becoming Duke of Windsor. She became Duchess of Windsor on June 3, 1937, in a small wedding in France at a château near Tours. Ostracized by the royal family . . . she and the new duke began cultivating the fine art of doing nothing during years of elegant exile.

Except during the duke's wartime service as Governor of the Bahamas, the couple looped constantly around the international social circuit. His faintly flashy clothes and her severe elegance became fashion standards. When she stopped wearing hats, so did everyone else. Wherever they went, with their large personal staff, mountains of luggage and pet dogs, they were accorded the regal status denied them in Britain. In return they offered the world a romantic fantasy of elegance and wealth.

It was not until 1967 that Queen Elizabeth II ended the couple's ostracism by inviting them to attend a ceremony in London commemorating the duke's mother, Queen Mary. Elizabeth paid the couple a visit in Paris in 1973 during her uncle's final illness. When he died shortly after, the duchess returned to England for the funeral and, at the Queen's invitation, stayed at Buckingham Palace.

While she was still able, she would end each day by walking into his empty room to whisper "Good night, David" to the man who had loved her.

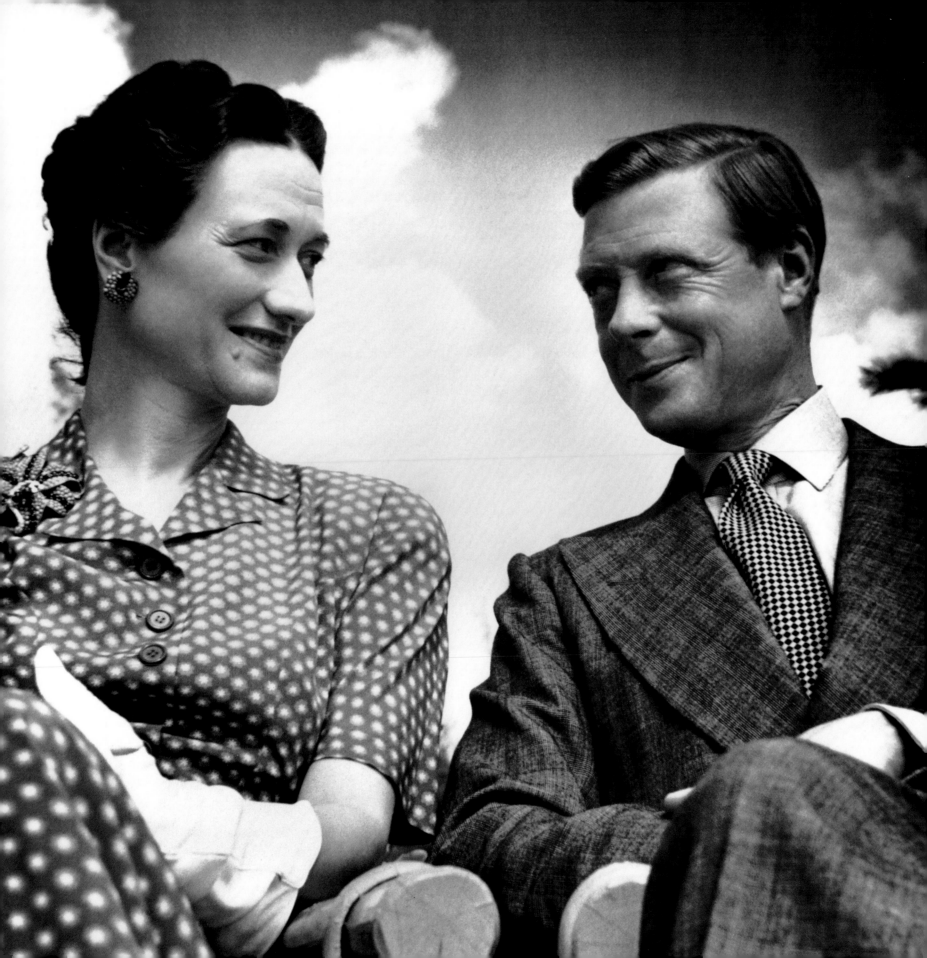

jean cocteau &
jean marais

by RANDALL KORAL

FRANCE'S LAST GREAT LOVE STORY ended in the fall of 1998, with the death of Jean Marais. He had been a fine actor and a genuine war hero. But he never minded—even seemed to prefer—when people identified him as the "companion" of Jean Cocteau, who had died in 1963. "Even today," Marais said in his last interview, "I still feel the same way about him. I feel almost certain he's here somewhere. He lives with me." In life they shared an apartment in Paris, then a country house in Milly-la-Forêt. There was a 24-year age difference between them. Cocteau once said, "I am his slave and his king." Marais inspired Cocteau to become interested in making films. "You're a hero" Cocteau told him. "I'm going to create heroic roles for you."

The timing couldn't have been better for it. The year was 1943, the Nazis were installed in Paris, and France needed all the home-grown heroes it could get. "The Eternal Return," Cocteau's reworking of Tristan and Iseut starring Marais, was a hit. Marais and Cocteau once got into a scrape with a theatre critic outside a restaurant on the Boulevard des Batignolles. The unfortunate critic, Alain Laubreaux, had lambasted a Cocteau play; Marais duly leapt to his mentor's defense and pummeled the critic under a heavy spring rain. The incident provided fresh meat for the jackals who staffed Paris's collaborationist newspapers. Their subsequent attacks weren't confined to the couple's work for the stage. Marais and Cocteau were vilified for being unapologetically in love. Parisian audiences, on the other hand, were less disapproving. They were willing to take Jean Marais any way they could get him, though they preferred him as a swashbuckler in tights or togas. He might have become France's answer to Douglas Fairbanks or Ronald Reagan, but he couldn't keep away from the theater. He played Cyrano, d'Artagnan and Monte Cristo at the Comédie Française. And he always kept smart company. "The most beautiful show of my entire life," he recalled, "was the time I had lunch with Jean Genet, Sartre and Cocteau. It was a like a contest to see who could shine the brightest." Jean Genet once told Marais, "You'll be a success the day you play someone ugly." Cocteau, always happy to help, re-cast his beauty as Beast. "La Belle et la Bête" came out in 1945, and forever linked Cocteau and Marais in the public mind.

Opium is one of the few things that came between Marais and Cocteau. It explains why they weren't together on October 11, 1963, as Cocteau lay dying in Milly-la-Foret. Cocteau was supposed to stay at Marais's home (the couple had been living apart for several years), but the poet had taken up opium again, and he didn't want Marais to know. "I would have prepared his opium pipes for him, if that would have brought him some relief," Marais said afterward. "The doctors didn't understand that their morphine had no effect on him. It was only a pale imitation of his favorite drug." Marais was once asked, by a coquettish interviewer, what he would say if Cocteau were to come back to life for an evening. "I wouldn't say anything," Marais answered cooly. "I would kiss him."

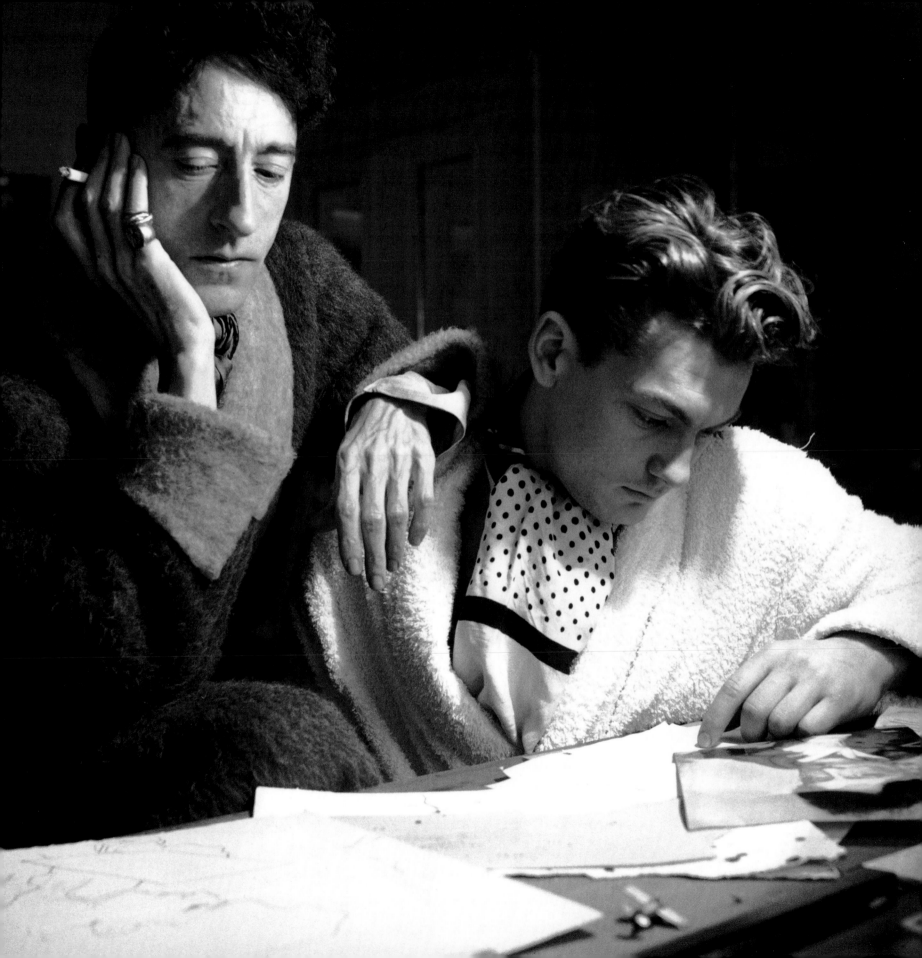

dylan & caitlin thomas

by DYLAN THOMAS

O CAITLIN CAITLIN CAITLIN my love my love, where are you & where am I and why haven't you written and I love you every second of every hour of every day & night. I love you. Caitlin. In all the hotel bedrooms I've been in in this two weeks, I've waited for you all the time. She can't be long now, I say to my damp miserable self, any minute now she'll be coming into the room: the most beautiful woman on the earth, and she is mine, & I am hers, until the end of the earth and long long after. Caitlin, I love you. Have you forgotten me? Do you hate me? Why don't you write? Two weeks may seem a small time but to me it's old as the hills & deep as my worship of you. Two weeks here, in this hot hell and I know nothing except that I'm waiting for you and that you never come. *Darling* Cat, my wife, my beautiful Cat. And in two weeks I've traveled all over the stinking place, even into the deep South: in 14 days I've given 14 readings, & am spending as little as possible so that I can bring some money home and so that we can go into the sun.

Now I'm back in New York, for two days, in the same room we had. That was the last love & terror, because I *know* you are coming into this room, & I hide my heaps of candies, & I wait for you—like waiting for the light. Then I suddenly know you are not here; you are in Laugharne, with lonely Colm; & then the light goes out & I have to see you in the dark. I love you. *Please*, if you love me, write to me. Tell me, dear dear Cat. There is nothing to tell you other than that you know: I am profoundly in love with you, the only profundity I know. Every day's dull torture, & every night burning for you. Please please write. I'm enduring this awfulness with you behind my eyes. You tell me how awful it is, & I can see. But I *will* have Majorca money. Look Majorca up in the Encyclopedia in the Pelican. You think I don't understand grief & loneliness; I *do*, I understand yours & mine when we are not together. We shall be together. And, if you want it, we shall never be not together again. I said I worshipped you. I do; but I want you too. God, the nights are long & lonely.

I LOVE YOU, Oh, sweet Cat.

frank sinatra & ava gardner

by RICHARD JEROME

To REALLY SELL A TORCH SONG, a singer needs a torch. Frank Sinatra, master of the love ballad, found his flame in the sultry charms of Ava Gardner. For three explosive years the crooner and the actress fueled headlines, fascinated a nation and broke up the furniture with their free-for-all affair.

From the moment the 130-pound son of a Hoboken fireman spotted the 36-20-36 daughter of a North Carolina farmer on the MGM lot in the late 1940s, he was head over heels. "I'm going to marry that girl," he told a pal. She at first thought he was conceited and overpowering but soon found him irresistible.

"They loved fun, and they loved their quiet moments," says Kathryn Grayson, an old friend and costar of the pair. At parties in her Santa Monica house, she recalls, "they sat in the corner and held hands. They had their fights too."

The scrapping, in fact, never seemed to stop. "He has a temper that bursts into flames," said Gardner, "while my temper burns inside for hours." They quarreled over politics, music and, of course, other lovers. Frank was insanely jealous of Ava's second ex-husband, bandleader Artie Shaw (Mickey Rooney was her first). When he found Shaw with her one night in 1950, Sinatra fired two shots—into his own mattress. For her part, Ava wanted Frank to get out of his unspooling 11-year marriage (Frank dragged his heels), and she once stormed out of a club when she thought Sinatra was singing to actress Marilyn Maxwell. "We were always great in bed," the salty Gardner once said. "The trouble usually started on the way to the bidet."

Sinatra finally obtained a Nevada divorce and married Gardner 72 hours later on Nov. 1, 1951. Frank built Ava a shower in the scorching desert and lavished gifts, including a diamond ring, on her for their first wedding anniversary. When she found out that Sinatra was broke, she said to cameraman Robert Surtees, "You know what the son-of-a-bitch did? I got the bill for the ring!"

By 1953, Sinatra was back on top. He won an Oscar for his portrayal of Maggio, the drunken soldier in *From Here to Eternity.* Soon he was busy with other films and back in the recording studio. "Work took him in one direction and her in another," says Grayson. "They couldn't be together enough." Ava soon began losing interest in the relationship. Their separation was announced in October 1953, although they didn't finalize their divorce until 1957....

For many years, on sound stages and in dressing rooms, Sinatra kept a picture of Ava taped to his mirror. "They developed a great friendship," Grayson says. "They helped each other. I think they wanted to get together again, but circumstances kept them apart." Despite a lineup of bullfighters, playboys and actors, Gardner, who died in 1990 at age 67, never married again.

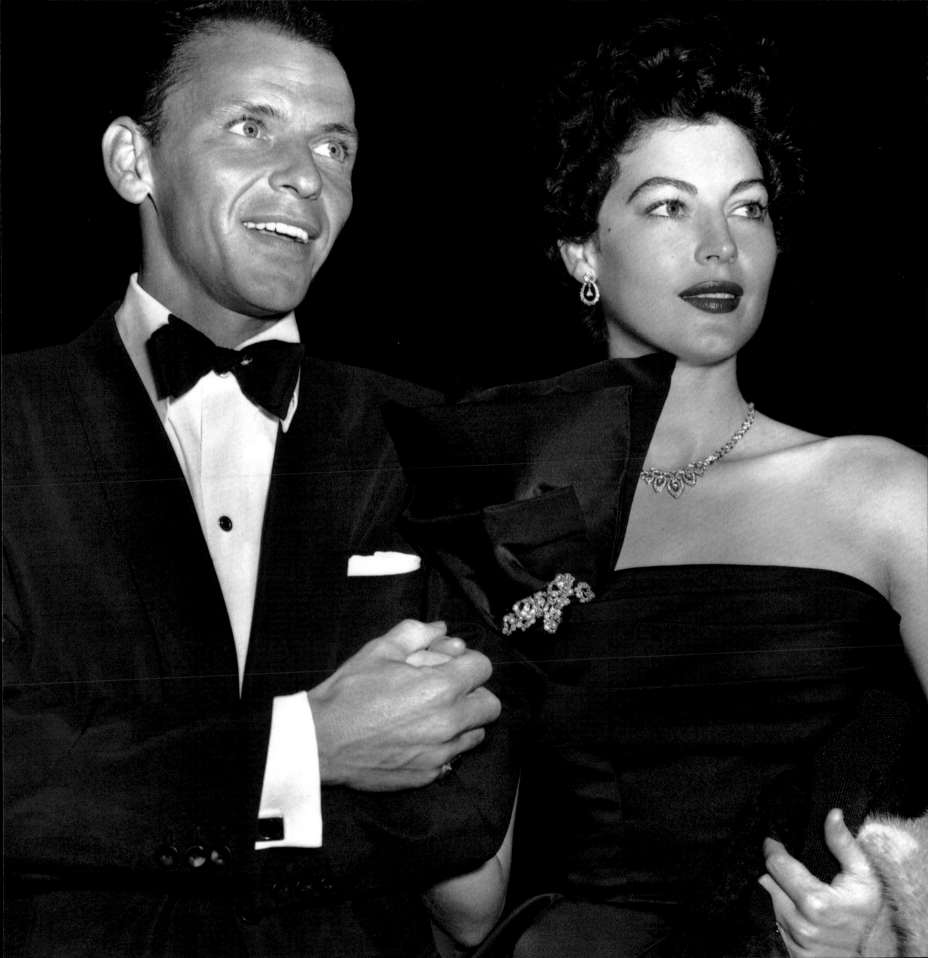

bonnie & clyde

by JANET WELLON

BONNIE AND CLYDE are perhaps the best known bad criminals of all time. By all accounts their career as bank robbers and kidnappers was a miserable failure that left scores of people (including themselves) dead or wounded in their wake. So how did they capture the fascination of the American public for the past fifty years? The 1967 movie starring Warren Beatty and Faye Dunaway contributed to the myth. But some argue that the public's interest in this couple stems from their unflagging devotion to each other. Despite prison, gun-shot wounds, fires, and the ardors of being on the run, Bonnie and Clyde were a team whose unlikely romance was as appealing as any star-crossed lovers fiction or history has offered up.

Clyde Chestnut Barrow was born in Telico, Texas, on 24 March, 1909. His first serious crime came in November 1929 when he and his brother Buck committed a series of burglaries in Henrietta and Denton, Texas. About the same time, Clyde paid a visit to a girlfriend who had broken an arm after falling on a patch of ice. Attending to her was her friend and neighbor, Bonnie Parker. The attraction between her and Clyde took hold immediately, and despite the fact she was still technically married to a man serving a life sentence, she became his lover and almost constant companion. The team would become the most infamous outlaws since Frank and Jesse James.

Barrow was a rather small man; standing only 5'7" and weighing 130 pounds, and it is said that his initial attraction to Bonnie was her similar small stature. At only 4'10" tall and weighing a mere 85 pounds, Bonnie made Clyde look positively strapping. His ego satisfied, it seemed to him that he had found his soul-mate. Before long they had committed several burglaries and auto-thefts together in the Dallas area. Clyde was, however, no criminal mastermind and was caught and jailed many times. But Bonnie remained loyal and along with varying members of the Barrow Gang, was always first to greet Clyde when he was released from jail, eager for another caper.

Their love for each other has never been in question. Their love life, however, is the issue of some debate. Some reports claim that Clyde was a homosexual who was devoted to Bonnie but was sexually involved with a male gang member, W.D. Jones.

On June 10, 1933, Bonnie, Clyde and Jones crashed their car. Bonnie was trapped inside. The outlaws, with the aid of some local farmers who saw the crash, pried her free, but not before her leg had been seriously burned. She never walked without aid again. During her convalescence, Clyde would not leave her side, so Buck and Jones robbed local businesses to pay for her medical bills.

The end of the story came on May 23, 1934, near Gibsland, Louisiana, where Bonnie and Clyde were shot to death in a road-side ambush. Only a month earlier, Bonnie's mother gave her a love poem she had just completed: "The Story of Bonnie and Clyde."

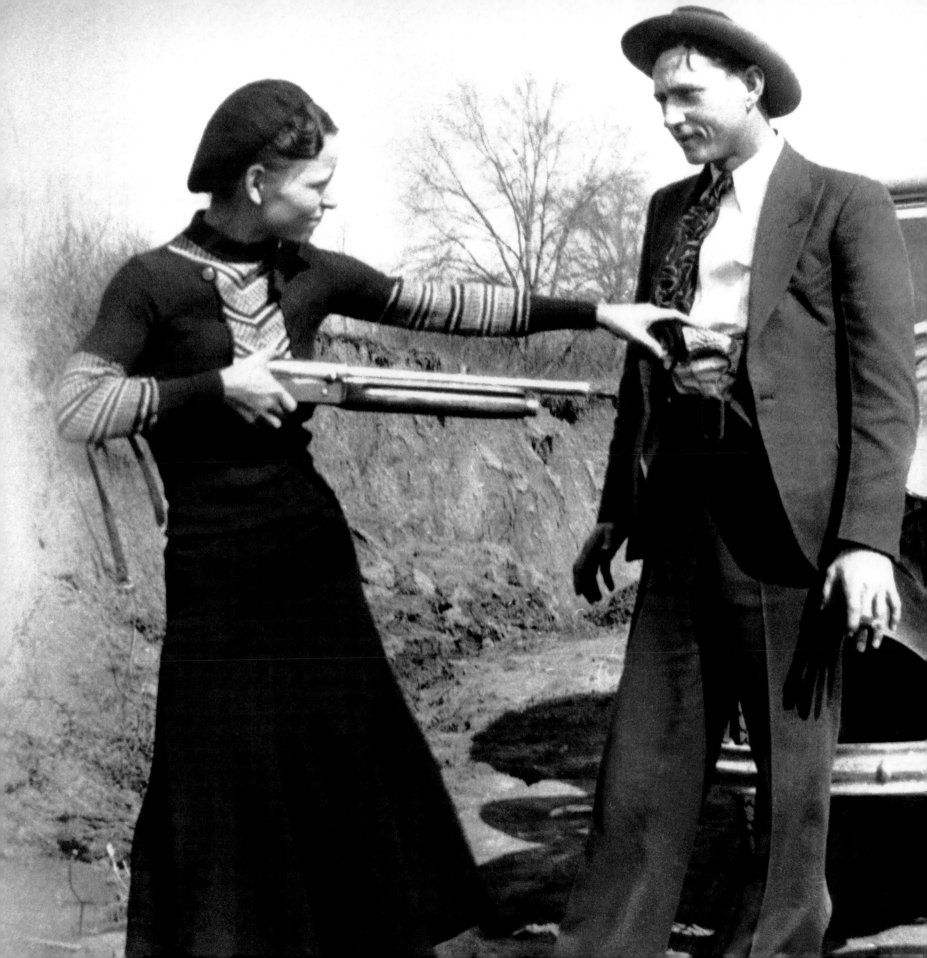

king hussein &
queen noor

by DOROTHY ROMPALSKE

LISA HALABY HAD BEEN FORMALLY introduced to King Hussein in January 1977 at the dedication ceremony of new airport facilities she'd helped to design in Amman, Jordan's capital. In the spring of 1978 the king renewed Lisa's acquaintance, whisking her off for romantic moonlit rides through the hills of Amman on the back of his BMW motorcycle. After a secret six-week courtship, the monarch proposed and Lisa accepted, brushing aside her reservations about marrying into his royal family. As she told the *New York Times Magazine,* "I was unsure I would be exactly what he needed, that I wouldn't be a hindrance, being relatively new to Jordan and because it happened fairly quickly." True love, however, ruled the day and the couple were married in a small, private ceremony in Amman on June 15, 1978.

Shortly before the marriage, Lisa, who had been a nonpracticing Protestant, converted to Islam. The Arabic name the king chose for her, Noor al-Hussein (meaning "light of Hussein"), seemed appropriate beyond the obvious allusion to her crown of golden hair. Lisa's presence had indeed become a light in Hussein's life, lifting the king, at age 40, from the depression he'd fallen into while mourning the loss of his third wife, Queen Alia, who'd died tragically in a helicopter crash in 1977.

The whirlwind courtship between the willowy beauty and the dashing, intense king, set against the backdrop of one of the world's oldest and most picturesque cities, captured the imagination of the American public. There were frequent references in the press to another U.S. blond who'd made a royal match, Princess Grace of Monaco. Queen Noor, however, was said to be annoyed by the comparison, and she made it clear in several interviews that she was not living a fairy-tale existence. Unlike Grace Kelly, who became princess of a peaceful resort kingdom, Lisa Halaby had married into a troubled country at the center of a volatile region.

For Jordanian conservatives, the American-born Noor was a controversial choice for queen. Before her, by tradition, only full-blooded Arabs had held the title of Queen of Jordan.... Noor's determination (with the king's encouragement) to be the country's first queen with an active role in her husband's government defied still more conventions. She is the first one to have an office on the grounds of the royal palace, from which she works full time on the issues that concern her most—community development, education, women's rights, the environment, and world hunger.

Recent rumors of discord in the royal marriage, and reports that the king has what the press euphemistically calls "a wandering eye," may be painful for Noor, but she has handled them with the characteristic dignity and discretion she's demonstrated since the beginning of her reign. For while fate may have chosen a beautiful all-American girl to be queen of an Arab nation, this brilliant woman is wise enough to know that life, after all, is not a fairy tale.

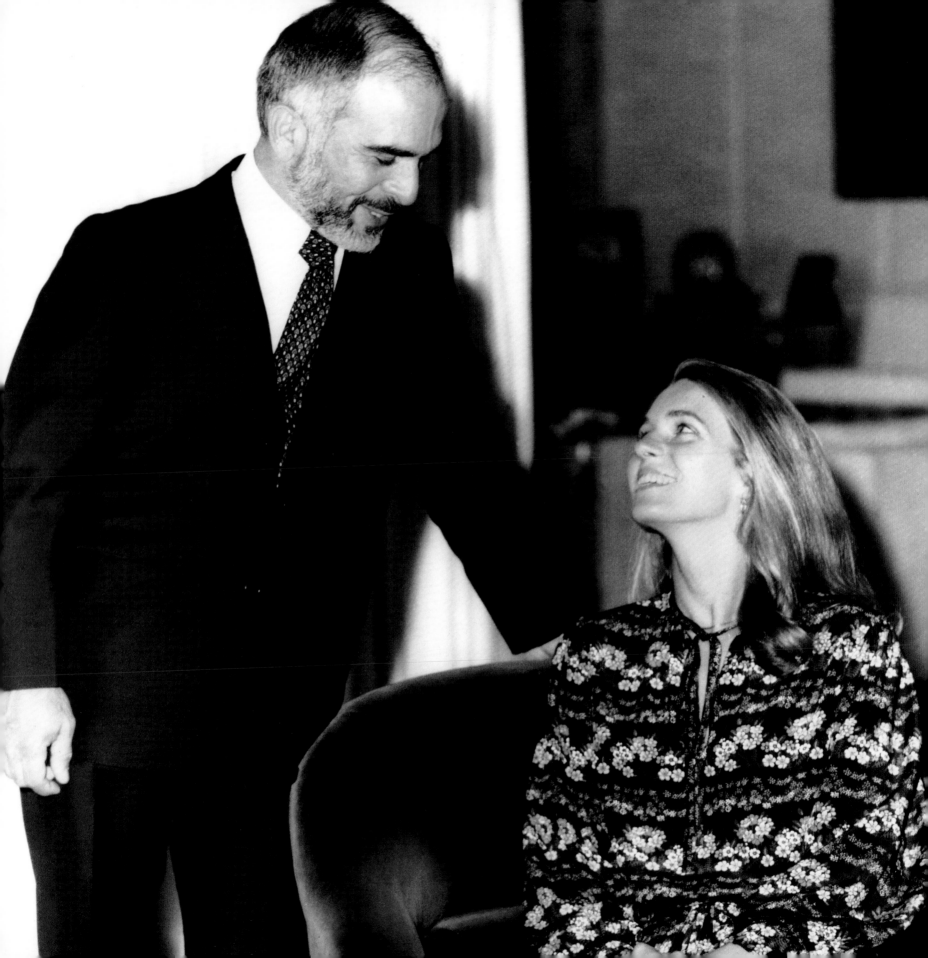

robert wagner &
natalie wood

by EDWARD Z. EPSTEIN

I'M GOING TO MARRY THAT MAN," Natalie had said at age eleven, after spotting spectacularly handsome, nineteen-year-old heartthrob Robert Wagner in the studio commissary. She was eighteen and he twenty-six when they began seriously dating (they'd had a few dates just before Natalie became involved with Elvis). Wagner was—at the moment—Hollywood's most glamorous bachelor: clean-cut and immaculately groomed, with a million-dollar smile that melted the hearts of scores of teenage movie fans.

The pairing of Natalie and Wagner—known as R.J. to his friends (he called Natalie "Tiger" and "Nate")—was totally "appropriate" in their respective studios' eyes. The couple's courtship struck publicity gold, but more important, they really *liked* each other. "This was the couple that invented 'togetherness,'" recalled Hedda Hopper. "In private or in public, it made no difference; they held hands, kissed, clutched each other in an altogether-nauseating display of coltish affection." Indeed, Natalie and R.J. were in love, and . . . were married on December 28 [1957]. From the very start, their relationship faced obstacles, most notably, balancing two film careers while trying to maintain a personal life under the unrelenting scrutiny of the Hollywood press corps.

To help her cope with burgeoning responsibilities, Natalie—over Wagner's objections—turned to a therapist. On the professional front, the newlyweds decided to cash in at the box office by making a movie together, *All the Fine Young Cannibals.* Hopes were high, but the picture bombed, its failure a portent of things to come in their relationship.

Wood filed for divorce from Wagner in . . . 1962. They'd been married for more than four years, and Wagner was heartbroken. Natalie and R.J.'s paths crossed several times in the years following their divorce. Slowly, privately, they discovered that love was lovelier the second time around. On July 6, 1972, aboard a yacht with only family and friends present, R.J. and Natalie retied the knot, a decade after they'd been divorced.

On a quiet Sunday morning—November 29, 1981—tragedy struck Beautiful, vibrant Natalie Wood, the diminutive, dark-eyed brunette who personified glamour for generations of filmgoers, was found dead—drowned—off the coast of California's Catalina Island. What had happened? There were conflicting reports, unanswered questions. . . . Sadly, given the many unexplained circumstances surrounding her death, Natalie's worst fears had been realized: She'd always had a morbid fear of the water, and she'd always gone to great lengths to avoid scandal.

The aftermath of that weekend proved incredibly painful for Wagner and the family. For several years, lurid tabloid coverage of Natalie's "mystery" death at age forty-three resurfaced periodically.

Images of Natalie are not easily forgotten. Her vitality and vivid screen presence endure. Years after her death, Lieutenant Roger Smith [who discovered Wood's body] said that when he watched Natalie's movies, "it bothered me for a long time. . . . Her eyes are so dark, and you just kind of look into Natalie Wood's eyes, and that's the way all her movies are. . . ."

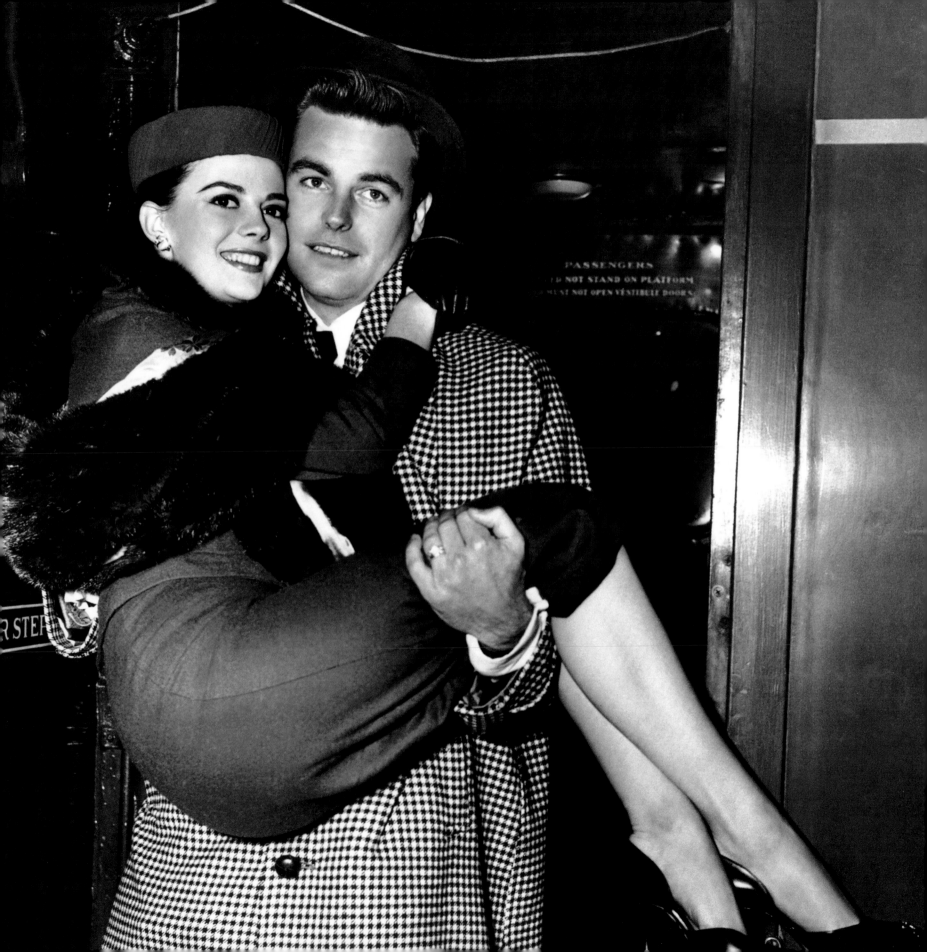

paul & linda mccartney

by JORDAN WALKER

LIKE NEARLY EVERYTHING ELSE they touched, Paul and Linda McCartney's 30-year marriage was an unqualified success. Amid the mania of the '60s and '70s rock 'n' roll lifestyle, Paul and Linda were an anomaly: they were content; satisfied with life and satisfied with each other.

The two are perhaps most remarkable for how unremarkable they managed to keep their lives. In the sense that they rarely supplied fodder for gossip, or created dramatic scenes in public, or jumped on any political or religious soap boxes, they were the anti-John and Yoko. Perhaps *because* of the attention heaped upon Yoko Ono, Linda's life as a Beatle-wife was overshadowed. After all, when she joined Wings—Paul's project after the Beatles—with very little musical experience, the backlash was nothing compared to what Yoko experienced. Even when Linda did espouse various causes (such as vegetarianism), there never was much made of it. Quiet, private, wealthy, famous beyond anyone's comprehension, and madly in love, they managed to create a surprisingly sane environment for themselves and their children.

From the time they met at the Bag o'Nails night club in London in 1967 to the time of Linda's death from cancer in 1998, the two were nearly inseparable. As Paul has said: "...except for one enforced absence, we never spent a single night apart. When people asked why, we would say— 'What for?'"

When examining their lives together, it's hard not to be impressed by what they both accomplished individually and how unassuming they were about it. He is, after all, Sir Paul McCartney, founding member and chief collaborator of the most successful rock band in history. But it's Linda who was perhaps the more active. An accomplished photographer and avowed vegetarian, she published numerous books on both topics. As Paul noted in his public statement after her death, "All animals to her were like Disney characters and worthy of love and respect.... She found it hard to be impressed by the fact that she was Lady McCartney. When asked whether people called her Lady McCartney, she said, 'Somebody once did—I think.'"

In 1998, the ravages of breast and liver cancer took their toll on Linda. She died in Arizona at the age of 56.

Paul and their three children were by her side at the end. In his message to the world press he recounted those moments. "Finally, I said to her: 'You're up on your beautiful Appaloosa stallion. It's a fine spring day. We're riding through the woods. The bluebells are all out, and the sky is clear blue.' I had barely got to the end of the sentence, when she closed her eyes, and gently slipped away. She was unique and the world is a better place for having known her. Her message of love will live on in our hearts forever.

I love you, Linda."

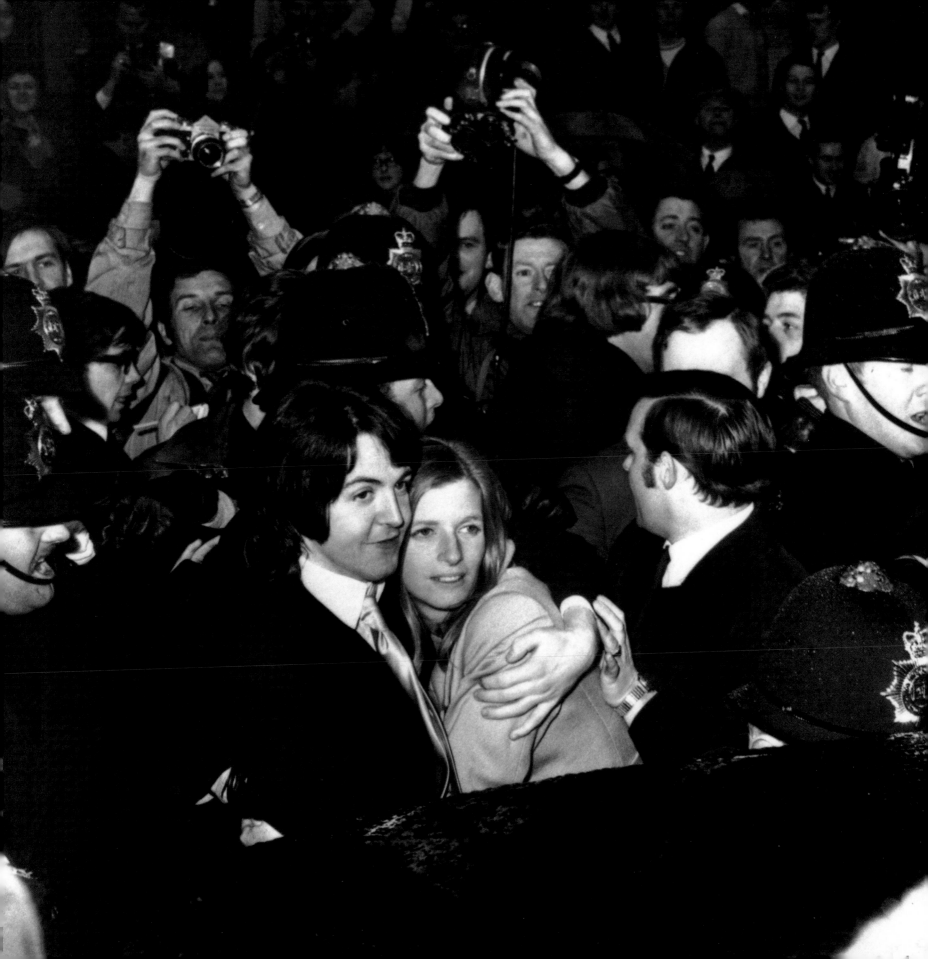

laurence olivier & vivien leigh

by JESSE LASKY, JR.

WHEN LAURENCE OLIVIER AND VIVIEN LEIGH went to Denmark to play in the Old Vic production of *Hamlet* in the summer of 1937, he was thirty and she twenty-three, and they were in love. It had all begun like this: the actress had first seen the actor posturing joyously in the 1934 production of *Theatre Royal.* His own bounding vitality blended with every flamboyant moustache twitch. Olivier got his first glimpse of Vivien Leigh the following year, in a play called *The Mask of Virtue.* The play's greatest virtue seems to have been Vivien herself. Those who saw her never forgot the impact of exquisite fragility and vivacity. She filled the stage with a beauty that stunned the mind.

The two did not meet until sometime later. She was dining with a theatre friend, John Buckmaster, at the Savoy Grill in London. Olivier was at a nearby table. Over a lobster Newburg and a glass of Les Forêts '34 they discussed the fact that Olivier had shaved his moustache.

"What an odd little thing Larry looks without it," observed Buckmaster disparagingly.

"Not in the least, Johnny!" Vivien protested. She wore the hint of a French hat perched low on her forehead, and all eyes in the room were on her and she knew it and was glad. She could feel Olivier's glance and of course found him madly attractive. "With or without a moustache," she insisted to Buckmaster. He then introduced the pair that were to become the most legendary couple in theater history.

In a whirlwind romance, the pair were married in Santa Barbara at the bungalows of San Ysidro Ranch. The justice of the peace had not been told just whom he was expected to marry. When the time arrived and they hadn't shown, the justice suggested that plenty of couples got stage fright before facing the altar.

"Somehow I don't think this couple will get stage fright," replied the best man. At that moment, the sound of a car brought them to the terrace. In the moonlight, Larry and Vivien came up the steps. "My God, it's Scarlett O'Hara! Why didn't you tell me!" exclaimed the justice.

Soon after their storybook marriage, Olivier became the king of theater, and Vivien, more in love with him than ever, desperately fought to share his throne. Then, shortly after her second Oscar for her performance as Blanche DuBois in the film version of Tennessee Williams's *A Streetcar Named Desire* (1951), Leigh began to display the signs of the mental illness that would darken her life until the end. Olivier, terrified that he might lose his hold on all he had if he allowed Vivien's illness to take over his life, began to remove himself from his life with her.

Eventually the couple were divorced, yet Leigh died with a photograph of Olivier at her bedside. And despite another marriage and great career success, Olivier always carried a deep ache of pity for her and for himself, and what they once were.

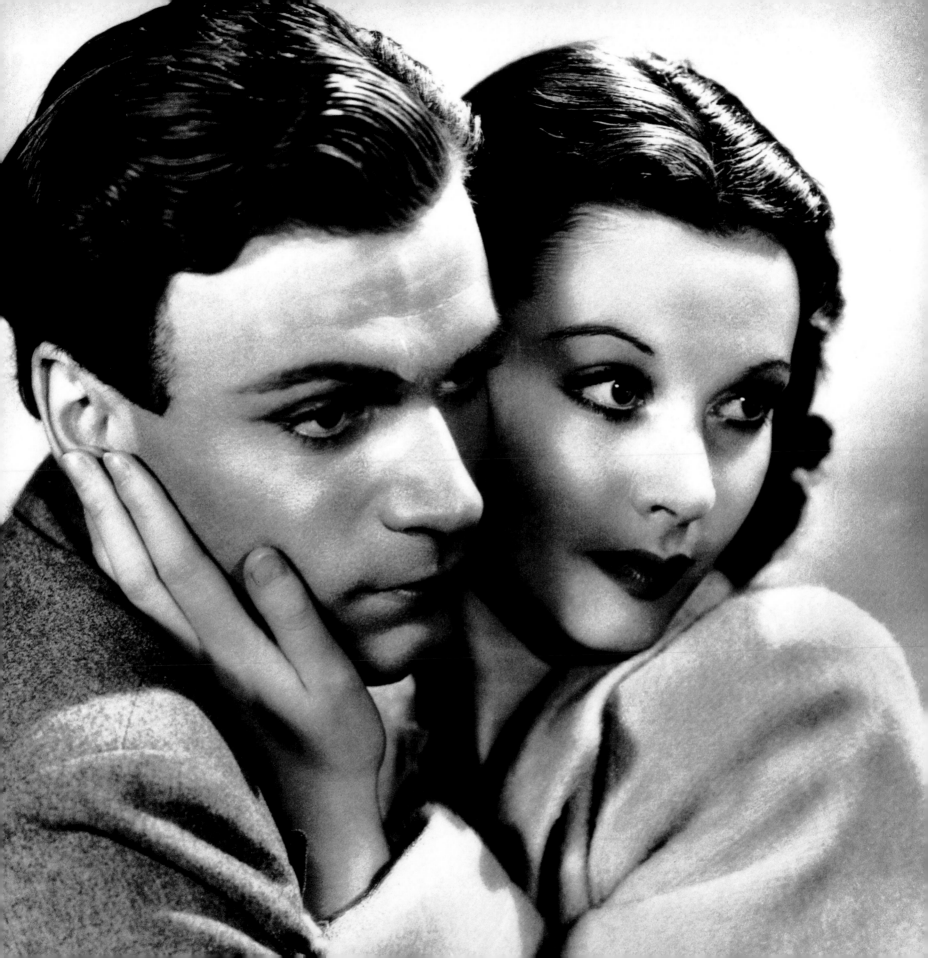

ellen degeneres & anne heche

by HILARY DE VRIES

O NE NIGHT LAST YEAR, Ellen DeGeneres had what she thought was an unremarkable dream. In it, she imagined she was trying to free a caged bird, only to discover that the bars of the cage had miraculously parted and the bird had escaped. But the dream proved to be prescient. Soon she would open her own cage with a series of dramatic gestures.

"When she told me that dream," recalls *Ellen* costar Joely Fisher, "I almost started crying because I knew what it meant, and I told her, 'Ellen, that's you, you're free now'."

Certainly it would seem so. Last April, DeGeneres's ABC sitcom, *Ellen*, scored its highest ratings ever with the episode in which her character, Ellen Morgan, came out as a lesbian. DeGeneres didn't stop there: She disclosed that she, too, was a lesbian and appeared on *Oprah* with her live-in girlfriend, actress Anne Heche....

"No one knows what we have together, no one," [DeGeneres] says, offering her hand to display three diamond rings, two of them worn on her left ring finger. "She surprised me with this one four days after we met," she says pointing to the antique solitaire. "She wanted to make the point that she wasn't joking around."

Although DeGeneres had been in long-term relationships with women before, it wasn't until she met Heche in March 1997 at *Vanity Fair*'s Academy Awards party and Heche moved into her house that she "learned the difference between love and being in love. I always used to be so envious of married people. Now this is it for me, for both of us, forever."

DeGeneres has no doubts about their relationship, despite media scrutiny, despite the jokes, like last spring's *Saturday Night Live* sketch satirizing their appearance together on *Oprah*. "We heard about that, but we ignored it like we ignore everything," she says easily. "Anne's taken a lot of flack for what she's done, but in 25 or 30 years, when we're still together and out of this business, we can look back and laugh. Maybe it's a horrible thing to say, but Anne and I both had the same reaction when Princess Di died, that she had just found the man of her dreams and then he died, and how could you go on living after that without that person? If Anne goes, I want to go, that's how strongly I feel."

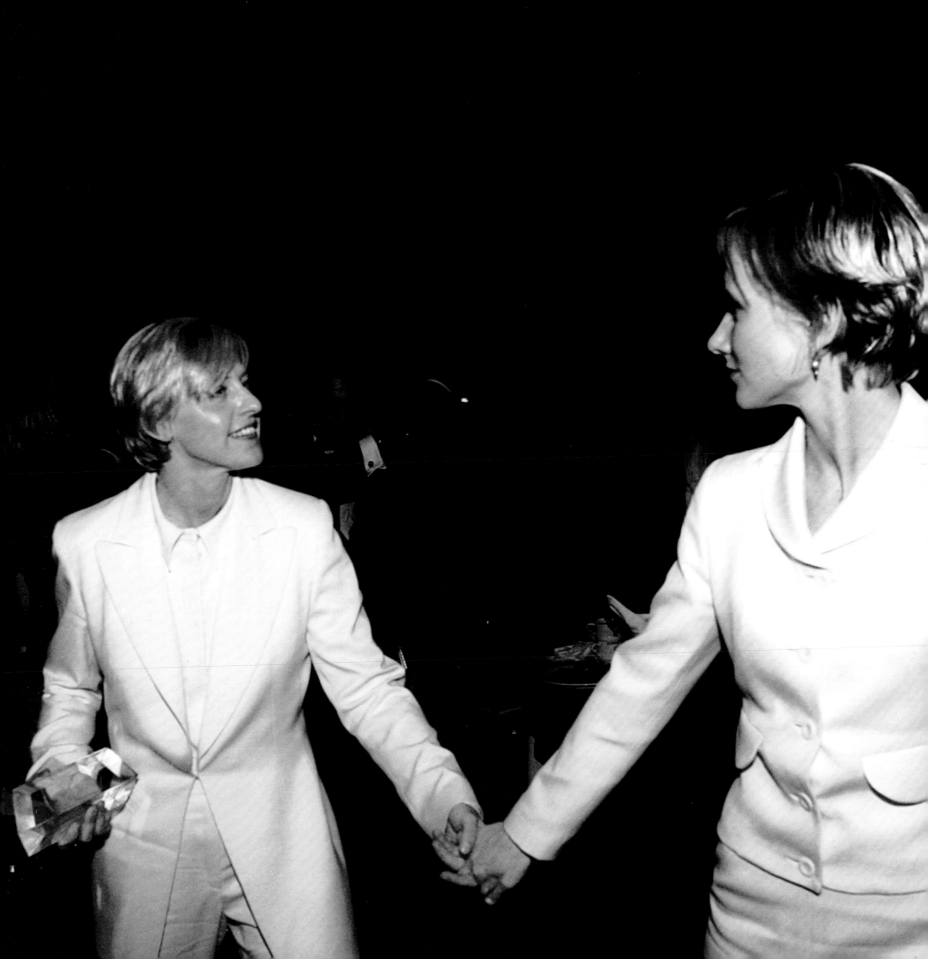

dashiell hammett & lillian hellman

by RICHARD LACAYO

LILLIAN HELLMAN WAS A 25-year-old aspiring screenwriter when she met Dashiell Hammett, 36 and already gray-haired, in a Hollywood restaurant in 1930, the year he published his greatest mystery, *The Maltese Falcon.* They embarked on what would turn out to be three tumultuous decades together, living high, writing intensely and experiencing, as she put it, "the pleasure of each other." They eventually got rid of their respective spouses.

"Dash" and Lillian were quick-witted, sharp-tongued and, in the early years, excessively fond of martinis. There are traces of them in Nick and Nora Charles, the sleuths in Hammett's 1932 classic *The Thin Man,* but with none of the Art Deco decorum. Hellman once smashed up the bar of a house where Hammett had assignations. And when Hellman asked for advice on her 1951 play *The Autumn Garden,* he read it and flung it in her face. "If you want to write like a hack," he snarled, "go live with someone else!"

"It was heavy going for them," says author and Hellman biographer Peter Feibleman, who became her lover after Hammett's death in 1961, "slugging it out and understanding what the rules were." Neither was interested in marriage or monogamy. "But there's a difference between infidelity and betrayal," says Feibleman, "and they knew it." They stood by each other, most courageously during the Communist witch-hunts of the '50s. Hammett, a former Party member, was proud to serve six months in federal prison in Ashland, Ky. Hellman, who supported leftist causes but never enlisted, "asked Hammett if he wanted her to go too," says Feibleman. "He told her, 'No. You'll die there. You have strength, not stamina. I have stamina'."

When he lost his stamina in a battle with lung cancer beginning in 1956, she installed a bed on the library floor of her Manhattan brownstone and nursed him until his death five years later.

Hellman, who died at age 79 in 1984, remained single. In the '40s, when one of her flings was threatening to turn permanent, she went to Hammett with her decision. "Well," she informed the writer, "I decided not to marry him." Hammett answered, "You needn't have bothered. I never would have let you."

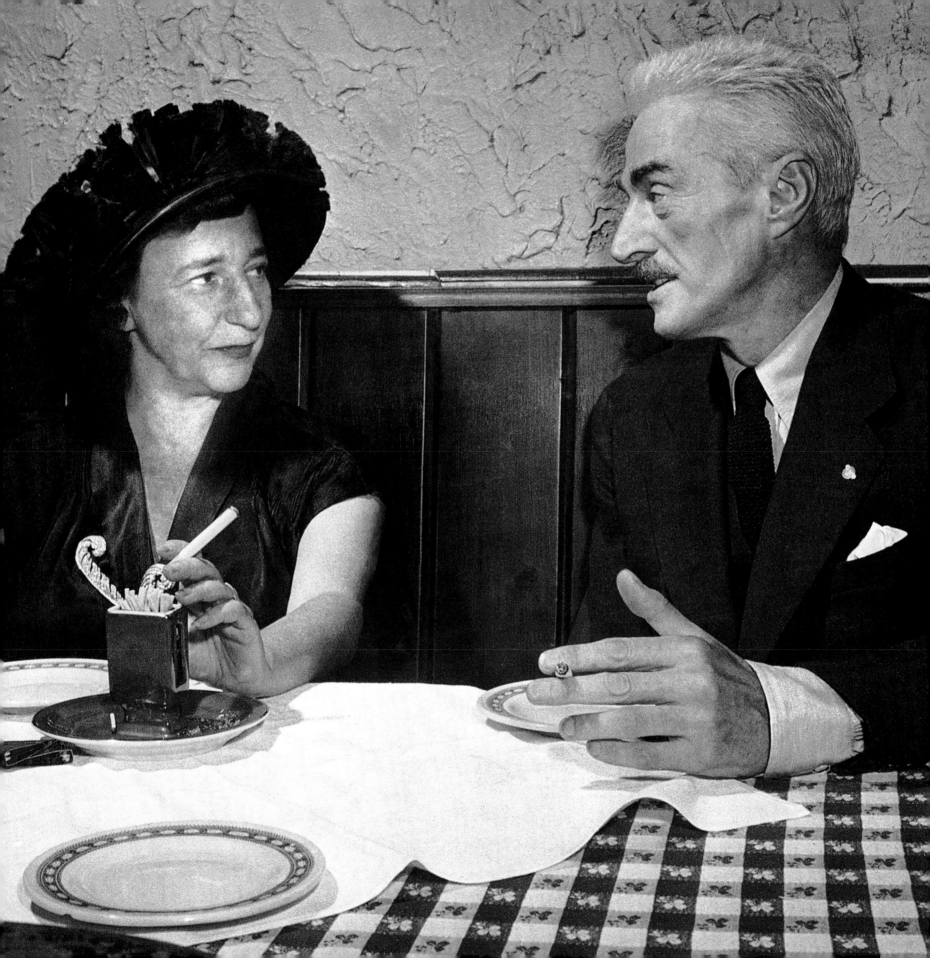

franklin & eleanor roosevelt

by DORIS KEARNS GOODWIN

WHEN ELEANOR ROOSEVELT journeyed to New York City a week after her husband's funeral in April 1945, a cluster of reporters were waiting at the door of her Washington Square apartment. "The story is over," she said simply, assuming that her words and opinions would no longer be of interest once her husband was dead and she was no longer First Lady. She could not have been more mistaken.

The only daughter of an alcoholic father and a beautiful but aloof mother who was openly disappointed by Eleanor's lack of a pretty face, Eleanor was plagued by insecurity and shyness. An early marriage to her handsome fifth cousin once removed, Franklin Roosevelt, increased her insecurity and took away her one source of confidence: her work in a New York City settlement house. "For 10 years, I was always just getting over having a baby or about to have another one," she later lamented, "so my occupations were considerably restricted."

But 13 years after her marriage, and after bearing six children, Eleanor resumed the search for her identity. For Eleanor a new path had opened, a possibility of standing apart from Franklin. No longer would she define herself solely in terms of his wants and needs. A new relationship was forged, on terms wholly different from the old.

She turned her energies to a variety of reformist organizations, joining a circle of postsuffrage feminists dedicated to the abolition of child labor, the establishment of a minimum wage and the passage of legislation to protect workers. In the process she discovered that she had talents—for public speaking, for organizing, for articulating social problems. She formed an extraordinary constellation of lifelong female friends, who helped to assuage an enduring sense of loneliness. When Franklin was paralyzed by polio in 1921, her political activism became an even more vital force. She became Franklin's "eyes and ears," traveling the country gathering the grassroots knowledge he needed to understand the people he governed.

They made an exceptional team. She was more earnest, less devious, less patient, less fun, more uncompromisingly moral; he possessed the more trustworthy political talent, the more finely tuned sense of timing, the better feel for the citizenry, the smarter understanding of how to get things done. But they were linked by indissoluble bonds. Together they mobilized the American people to effect enduring changes in the political and social landscape of the nation.

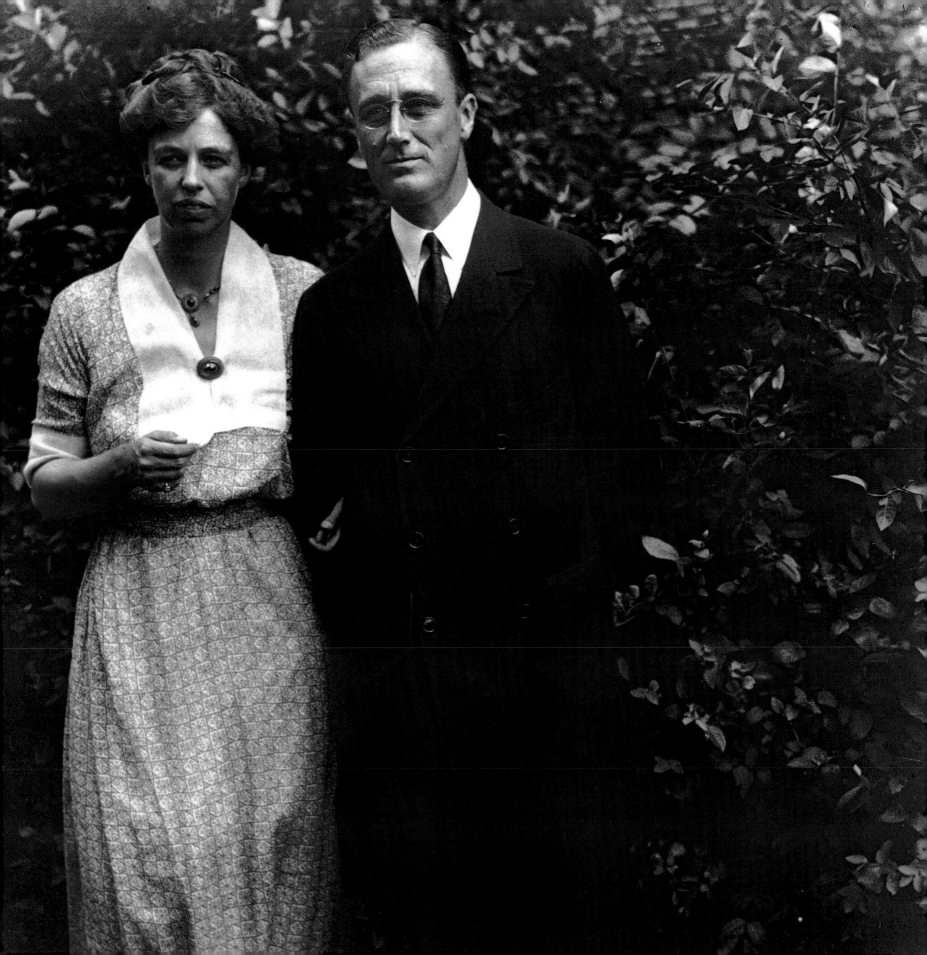

ted hughes & sylvia plath

by A. ALVAREZ

HEN SYLVIA PLATH COMMITTED SUICIDE, early in the morning on February II, 1963, she ceased to be merely a poet and became a symbol, a warning, a myth. For the feminists, Plath was a terrible example of the raw deal women must expect in a world dominated by men. Ted Hughes, they said, married her, then dumped her for another woman when she became troublesome, leaving her to cope on her own with their children and her demons.

I doubt that Plath would have seen herself that way. She was too talented and ambitious to want preferential treatment and, by the end, when the poems were pouring out unstoppably, sometimes three a day, she was too convinced of her achievement to need anyone's say-so. It was Hughes who was left with the consequences: public accusations of murder and treachery, his name hacked off her tombstone again and again.

Plath was a Fulbright Scholar at Cambridge when they met. This was in 1956, when life in England was still pinched and deprived, though she hated the unheated houses and lousy plumbing less than the snobbery and crushing putdowns. Hughes was not that kind of superior Englishman. Although he had been at Cambridge, he was a northerner, a country boy who knew about foxes and otters and hawks, and she had already fallen for his poetry before she met him. The attraction between them was mutual, their courtship brief and dramatic. For Hughes, Plath was "a new world. My new world," a land of impossible plenty.

Plath was already an accomplished poet when she met Hughes. She had won prizes and published at least as much as he had. Her poems were skillful, polished but frozen, "thin and brittle, the lines cold," he says. In comparison, Hughes had already arrived; he had a hot line open to whatever it was that made him tick. It didn't matter that sometime he used mumbo-jumbo to get where he wanted to be—astrology, hypnosis, Ouija boards, or the dottier forms of Jungian magical thinking. All that mattered was that the poems he fished out of the depths were shimmering with life, while the life in Plath's work was still locked away out of sight. Finally, provoked by his wife's violent and blind rage, he unwittingly handed her the key she had been looking for: " 'Marvelous!' I shouted. . . . 'That's the stuff you're keeping out of your poems!' " Always the good student, she went down into the cellarage, key in hand. But the ghouls she released were malign. They helped her write the great poems first collected in *Ariel*, but they destroyed her marriage, and then they destroyed her.

paul &
julia child

by NÖEL RILEY FITCH

THE COTTON DRESS CLUNG to her slim, six-feet-two-inch body. Here she was in China, a privileged girl, seeking adventure, even danger, in the civilian opportunities of World War II, and she had found it, not in the Registry of the Office of Strategic Services, but in the urbane, sophisticated, multilingual presence of forty-three-year-old Paul Child. They talked all evening, his intellect challenging her, his experienced touch awakening her. In the last China outpost of Lord Mountbatten's command, surrounded at sea by Japanese forces, warplanes droning in the distance, Julia McWilliams felt alive.

Paul was unlike the Western boys she hung around with in her large circle of friends in Southern California, unlike any of the men her friends married. The touch of his hand taught Julia how dough feels when it is plunged into boiling oil.... It was Julia who then took the initiative in love. She first wrote "I love you" and spoke of her "warm love lust." And she was the first to suggest a concrete plan of action: "Why don't you fly out about in August and drive across the continent with me? We could say we were meeting some friends in Needles." Paul responded immediately: "I want to see you, touch you, kiss you, talk with you, eat with you ... eat you, maybe. I have a Julie-need. Come on back and sit in my lap and let me bite your earrings again. I have never tasted such delicious pearls!—let other gourmets eat their oysters. I will take pearls (on your earlobes) and be more tantalizingly and magnificently fed than they. So to bed, pearl-hungry." The food references were the key metaphor of longing in part because Julia was regaling him with her cooking feats. "Why don't you come to Washington and be my cook—we can eat each other," he again suggested. "If I buy a Buckminster Fuller house will you come and cook for me and play the pianola?"

The entire [Child] family observed Julia's qualities, qualities that Paul listed in his last letter crossing the country. This first analysis of Julia remains the best we have. Though her balance and logic, which Paul praises, are McWilliams qualities she seriously cultivated to please him, the strong and natural woman he adored is the California girl she always was. In turn, Julia loved this close and devoted Child family. According to [neice] Rachel Child: "She bought the Child family and what it stood for and it stood for good eating and good wine and talk—preparation for the table, rituals." Most important, Julia was deeply in love with Paul. She always admired and respected him: she fell in love with him in China, but now she trusted him. She knew that if she gave Paul her life, he would not drop it. The rest seemed "inevitable."

"We are going to get married, and right away," Paul announced to his family.

"Well!" they said with one voice. "We thought you'd never come out with it!"

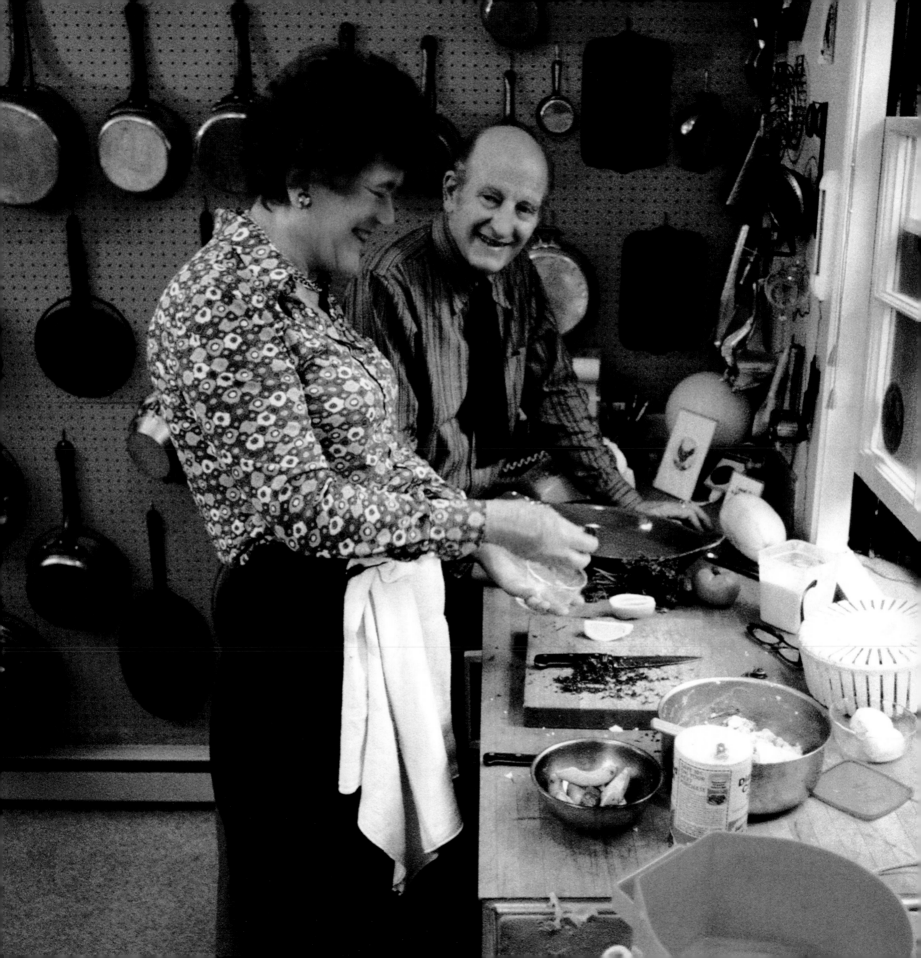

raymond carver &
tess gallagher

by TESS GALLAGHER

IT'S STEELHEAD SEASON, early January 1996. I've been rereading Ray's poems here at Sky House where he wrote so many of them. Below in the valley, men are walking the banks of Morse Creek, the river which became the central metaphor of *Where Water Comes Together with Other Water*.

Just yesterday our neighbor, Art LaMore, recalled Ray's amazing luck. One morning Ray had dropped a hook baited with salmon roe off the footbridge and caught a ten-pound steelhead. He'd carried it to Art's door, hooked over his finger by its gills, to show him. He had felt blessed beyond reason. By the time I came home, he'd cleaned the fish on the kitchen floor. There are still knife marks on the linoleum. Men fish for years on Morse Creek and never catch a steelhead. I don't think Ray knew this or cared. He simply accepted the gift.

We often walked along this river, sorting out the end of a story, as with "Errand," or discussing our plans for trips. Always we found release and comfort in noticing—that pair of herons, ducks breaking into flight upriver, the picked-over carcass of a bird near the footpath, snow on the mountains—the very kinds of attentiveness which binds his poems so effortlessly to our days. It was important, that walk, hyphenated by rests—his breath gathered inside him, again and again. We would talk quietly in those moments sitting on the ground, and I recall saying like a mantra, "It isn't far now." He was travelling on his remaining right lung, but carrying himself well in the effort, as if this were the way to do it, the way he had always done it. When we made it to the river mouth, there was an intake of joy for us both, to have crossed that ground. It was one of those actions that is so right it makes you able in another dimension, all the way back to the start of your life. We savored it, the river's freshwater outrush into salt water, that quiet standing up to life together, for as long as it was going to last....

For Ray, I think poems, like rivers, were places of recognition and healing:

Once I lay on the bank with my eyes closed, / listening to the sound the water made,
and to the wind in the tops of the trees. The same wind / that blows out on the Strait, but a different wind, too.
For a while I even let myself imagine I had died— / and that was all right, at least for a couple
of minutes, until it really sank in: *Dead*. / As I was lying there with my eyes closed,
just after I'd imagined what it might be like / if in fact I never got up again, I thought of you.
I opened my eyes then and got right up / and went back to being happy again.
I'm grateful to you, you see. I wanted to tell you.

Ray made the ecstatic seem ordinary, within reach of anyone. He also knew something essential which is too often sacrificed for lesser concerns—that poetry isn't simply reticence served up for what we meant to say. It's a place to be ample and grateful, to make room for those events and people closest to our hearts. "I wanted to tell you." And then he did.

desi arnaz & lucille ball

MICHAEL J. NEILL

S HE HAD HEARD A LOT about the Latin lover from New York City, but when Lucille Ball first laid eyes on Desi Arnaz on the set of the 1940 musical *Too Many Girls,* she concluded that someone had sold her a bill of goods. "Desi was in greasy makeup and old clothes, and I thought he wasn't so hot," Lucy later recalled. The feeling was mutual. "This is an ingenue?" Desi asked director George Abbott when he saw Lucy's bedraggled costume and fake black eye.

When they got past the makeup, though, the chemistry was irresistible. "You could tell the sparks were flying with Lucy," says Eddie Bracken, a costar in the film. "It happened so fast it seemed it wouldn't last. Everybody on the set made bets about how long it would last." But the 28-year-old B-movie queen and the 23-year-old Cuban bandleader were entranced. "She talked about Desi all the time," recalls [one] friend, actress Maureen O'Hara. "I said, 'Go ahead and marry him if you love him.' " Six months later they did, forming a union that would produce two children, an entertainment empire and one of the most watched television series of all time.

In the beginning, Lucy was rooted in Hollywood making movies, while Desi was on the road, first with the Army, then with his conga band. Desi's amorous flings didn't stop with marriage. (It was rumored he could rumba lying down and standing up.) The terrible fights that ensued led Lucy to file for divorce in 1944, but the Arnazes patched things up and did not then obtain a final decree.

Desperate for a way to spend more time together, which meant getting Desi off the road, the pair created *I Love Lucy.* The shooting schedule gave them a chance to work on their relationship and finally have children. "All their hopes, plans and dreams for a happy future were wrapped up in that TV sitcom," writes daughter Lucie Arnaz....

Like their TV counterparts, Lucy and Desi managed to create a cheerful life on their California ranch. But as their dynasty grew, Desi worked 14-hour days and spent weekends on his boat with his latest hot tamale. The stress wore on the marriage, with Desi often exploding in abusive fits of temper. Once Lucy aimed a gun at Desi's head and even pulled the trigger. When only a tiny flame spurted from the muzzle, Desi stepped up and lit his cigar.

"It got so bad that I thought it would be better for us not to be together," Lucy said in court when they divorced in 1960. Still, the public expected reconciliation: Lucy and Ricky always made up at the end of the show.

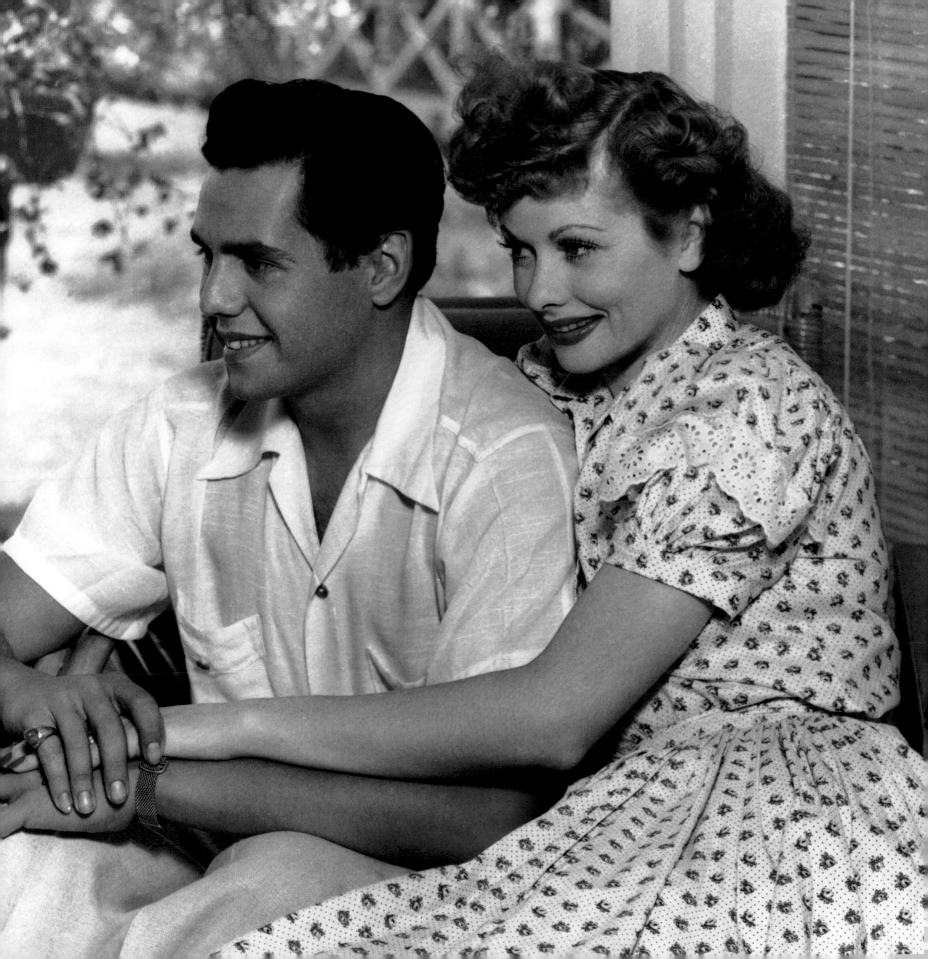

edmund wilson & mary mccarthy

by CAROL GELDERMAN

PERHAPS BECAUSE HE HAD AGREED to write a piece for the first issue of the revived *Partisan Review*, Edmund Wilson asked to meet the editors. When he came around to the office on a Saturday morning in October 1937, they took him to a nearby dive for a drink. McCarthy today remembers her odd choice of morning costume—a black couture dress with bands of fagoting, topped by a silver-fox fur—and that Wilson did not drink. Two or three weeks later Margaret Marshall phoned her. "You know, I've heard from Edmund Wilson," Marshall said, "and he wants to take you and me to dinner. I wonder why he's interested in me." McCarthy agreed to meet Marshall and Wilson at an Italian restaurant named Mary's, and then told the "boys" at *Partisan Review*. They were aghast, afraid that she would discredit them before they managed to get out one issue.

Because McCarthy had concluded that Wilson was not a drinker, she got Fred Dupee to take her to a bar before the appointed dinner. He bought her several daiquiris, wished her well, and sped her on her way to the restaurant. In no time, she discovered that Wilson drank copiously. Before dinner he ordered several double Manhattans for himself and his two guests, wine with dinner, and B and Bs after. McCarthy progressed from tipsy to high to drunk in quick succession, but not before telling Wilson the story of her life. When she woke up the next morning in a room at the Chelsea Hotel and looked apprehensively at the figure in the bed, she was relieved to find Margaret Marshall. "Oh, I've disgraced *Partisan Review*," she cried to her startled roommate.

The next week they did meet in New York, as Wilson was on his way to spend Christmas with his mother in the house he had grown up in in Red Bank, New Jersey. Wilson's stopover made her "very merry inside," she wrote him. She had to check herself from smiling openly in the subway and on the street. "I think you're wonderful. I miss you." [In January] Mary wrote to tell Wilson that she "must be a little bit in love.... I think you're wonderful. I can't resist saying it, naively, like that." Two weeks later a small paragraph in a New York tabloid announced: "Edmund Wilson and Mary McCarthy are to be married in New Jersey Thursday and will make their home near Stamford, Connecticut."

In fact, the elopement took the whole *Partisan Review* group by surprise.... In matters both large and small, the two were very unlike. Wilson intimidated people, never engaging in small talk, but relentlessly quizzing those who happened to know something about a subject that interested him. McCarthy attracted people with her gregarious and optimistic nature. He was brusque and impatient in manner, incisive and abrupt in speech, and he delivered lectures—his chief means of communication—even to close friends. She was courteous and thoughtful, and an attentive listener.... Despite their shared desire for stability, the marriage, his third and her second, was doomed from the start.

sid vicious & nancy spungen

by J.D. REED

IT IS SAID THAT THE SHABBY rooms of New York City's fabled Chelsea Hotel are inhabited by ghosts—of Mark Twain, Janis Joplin and other luminaries who once occupied them. But none of the wandering souls could tell a more haunting tale than the spirits of Nancy Spungen and her lover, Sid Vicious. For it was in the early morning hours of October 12, 1978, in room 100, that Sid ended his tempestuous 21-month relationship with Nancy by stabbing her to death with a hunting knife. Four months later, in agony without her, he ended his own tortured life as well.

At the time, Sid was 21 years old. As bass player for the Sex Pistols, which had broken up a year earlier, he was a member of one of Britain's most influential and incendiary punk-rock bands. Nancy, 20, had been his most ardent fan. Together, the couple were in the forefront of rock's avant-garde, two dog-collared nihilists who brought their twisted, gothic romance to its ill-fated end....

They moved into a flat, not far from Buckingham Palace, sharing a mattress on the dining room floor. "Everybody wanted to be with Sid, but unfortunately he came with Nancy," says [friend Pamela] Rooke, now a veterinary nurse on the southern coast of England. "She was unbelievably thick-skinned, one of the most unlikable people I've met. Everybody could see through her—except Sid."

On the morning of October 12, responding to a report of a domestic dispute, police entered their Chelsea Hotel room and found Spungen, clad in blood-soaked bra and panties, crumpled under the bathroom sink, dead of a single, deep stab wound to her abdomen. Sid, in a drugged haze, was charged with her murder and released on $50,000 bail. In several telephone calls to Nancy's mother Deborah Spungen after his arrest, Sid "never said he was sorry," she recalls. "He never said anything about it happening at all." Ten days later, Sid attempted suicide, slashing the full length of his forearm with a knife and reportedly screaming, "I want to be with Nancy! I want to be left alone!"

Although authorities never officially determined whether Sid's eventual death was by accident or design, Sid's mother Anne Beverly has little doubt. As evidence, she offers the worn piece of paper on which Sid scrawled a poem, simply titled "Nancy," to his departed love: "You were my little baby girl/And I knew all your fears/Such joy to hold you in my arms/And kiss away your tears/But now you're gone/There's only pain/And nothing I can do/And I don't want to live this life/If I can't live for you."

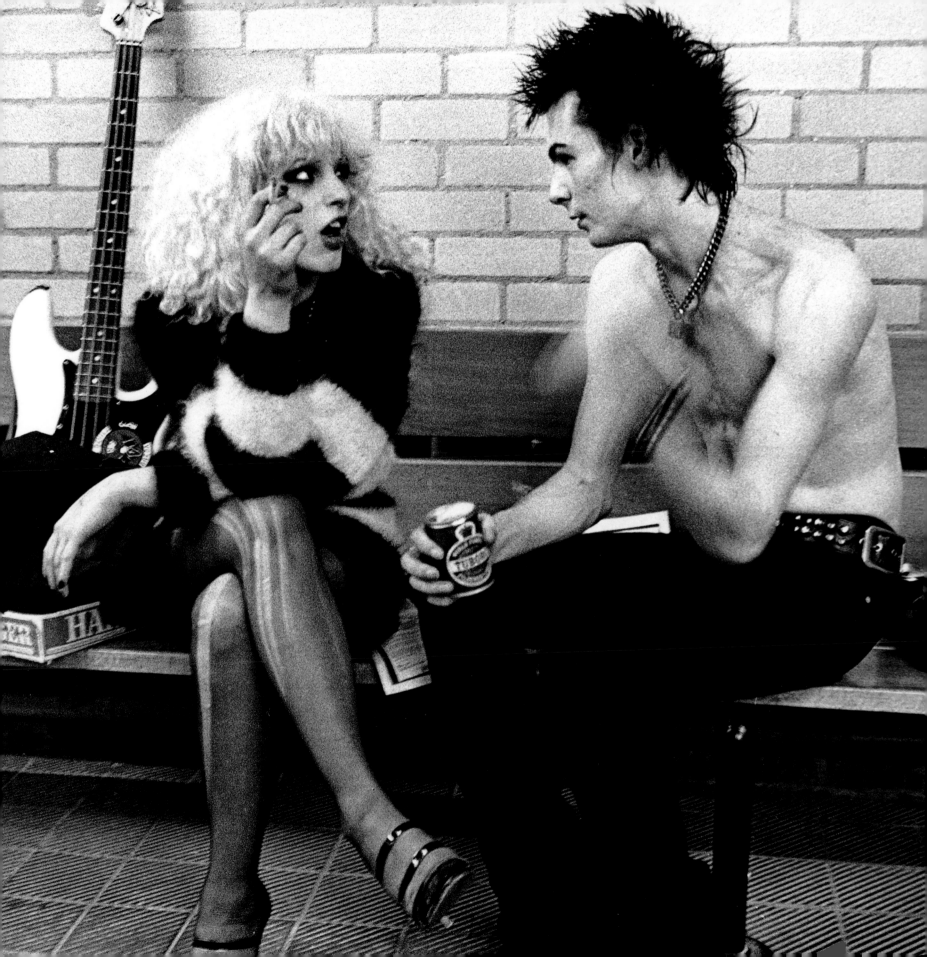

ronald & nancy reagan

by CYNTHIA SANZ

I T BECAME KNOWN SIMPLY AS "the gaze," that long, adoring look she directed toward her husband whenever Ronald Reagan stood to give a speech. Whether he was addressing his fellow members of the Screen Actors Guild or a joint session of Congress, Nancy was always there, eyes uplifted, pride radiating out of every pore. "Some of the reporters who wrote about me felt that our marriage was at least partly an act," the former First Lady wrote in her 1989 autobiography, *My Turn.* "But it wasn't—and it isn't."

Indeed, when it came to their love for each other, Ron and Nancy never had to pretend. They had "probably the greatest love affair in the history of the American Presidency," says their friend Charlton Heston. . . .

At the White House, the two seldom walked together without holding hands and regularly had their dinner sent to their living quarters on trays so they could catch up on each other's day. "Absolutely the first thing he did every night when he came upstairs to the residence was talk to Nancy," remembers Sheila Tate, the former First Lady's press secretary. "He enjoyed just being with her."

That was equally evident on the campaign trail, where their goodbye kisses evoked blushes from even the most hard-bitten observers. "We would turn aside because we felt that there was something very special and private and wonderful going on between the two of them," recalls Chris Wallace, then an NBC White House correspondent.

When they couldn't be together, Ron left love notes on Nancy's desk, often signing them I.T.W.W.W., "as in 'I love you more than anything *in the whole wide world*,' " Nancy would say. And on her birthday he sent flowers to her mother—"to thank her for giving birth" to his wife. . . .

As a 26-year-old starlet in Hollywood in 1949, Nancy was distressed to see her then-name, Nancy Davis, on a list of Communist sympathizers. Though her studio, MGM, promptly placed an item in a gossip column noting that she was not *that* Nancy Davis, the future politician's wife saw opportunity in the mix-up. She knew that Ronald Reagan, 38, the president of the Screen Actors Guild, was a staunch anti-Communist who would certainly sympathize with her predicament. Nancy cajoled a director friend, Mervyn LeRoy, into calling Reagan and getting him to invite her to dinner, ostensibly to discuss her situation. . . . By the spring of 1952, Reagan took the plunge, "One night over dinner, I said, 'Let's get married,' " he recalled in his autobiography, *An American Life.* "She deserved a more romantic proposal than that, but—bless her—she put her hand on mine, looked into my eyes and said, 'Let's.' "

In recent years, of course, Nancy has had to give even more. Since the former President's diagnosis of Alzheimer's, she has been managing what she has called his "long goodbye. . . ." "He is her hero, she is his heroine. They are devoted to one another," says Nancy's friend Aileen Mehle, the *Women's Wear Daily* columnist known as Suzy. "And especially now, Nancy is devotion itself."

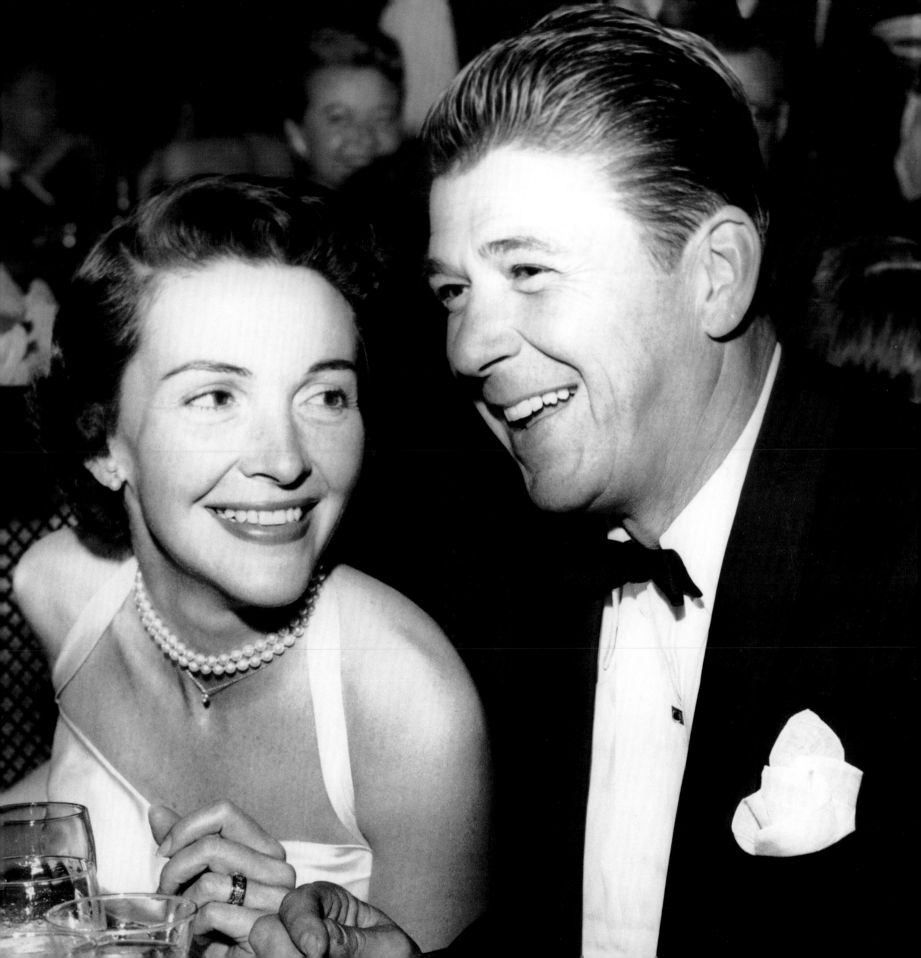

louis malle & candice bergen

by ROGER ROSENBLATT

C ANDICE BERGEN PAYS very careful attention to her 12-year marriage to Louis Malle, which, in spite of its odd schedule, seems to work quite well. "Each is the only person the other could have married," says Alice Arlen, who wrote the filmscript for Malle's *Alamo Bay*. Arlen observes how remarkable the two of them are, how quick-minded and quick-witted, how unimpressed by money and flashy displays. It would take extraordinary people to survive, much less flourish in, a marriage that has Malle living in Paris most of the year, with a few brief conjugal visits to L.A., until the summer, when Bergen's *Murphy* takes a rest. Malle detests L.A., and as a practical matter the writer-director of *Au Revoir les Enfants* could never do the kind of movies in Hollywood he does in France. For her part, Bergen would not have him functioning as a sidecar to her career.

But the marriage may actually thrive because of its separations. Bergen is suffused with common sense. Malle, born to French upper-middle-classness verging on aristocracy, lives in perpetual motion, the way that spoiled and gifted children sometimes do. He darts from idea to idea, project to project—"LouisLouisLouis!"— like a wren. The pace has its costs. In early October, Malle had surgery to replace a valve in his heart. The operation, successful, was performed in L.A. and Bergen was with him.

One reason the marriage succeeds is that it does not require high maintenance, perhaps because as individuals they don't, either. Another is that they fit together well. "They have a deep respect for each other," says the literary agent Ed Victor. "No one is according the other anything automatically." Another friend notes, "Louis is a romantic masquerading as a cynic. Candy is the reverse."

clark gable &
carole lombard

by SOPHFRONIA SCOTT GREGORY

LIKE MANY SHOWBIZ PAIRS, they looked too good together to be true. Tall, blonde and fiery-eyed, Carole Lombard epitomized 1930s glamour; Clark Gable, with his broad shoulders and devil's grin, seemed every inch his nickname—the King. But the queen of comedies, who swore freely and loved practical jokes, and her rough-and-ready leading man were more than just Golden Age window dressing. The love they shared for six years was that Hollywood rarity: the real thing.

"They had an ineffable quality in romance, the ability to have fun together," says actress Esther Williams, an MGM contract player like Gable. "They were soul mates who thought life was delicious, and they made everyone's life delicious around them."

By any measure, they had plenty to savor—even before they found each other. When the 28-year-old Lombard caught Gable's eye at a Hollywood party in 1936, she was one of the highest-paid actresses in America, pulling in $465,000 one year for three movies and three radio shows. Gable, the star of *It Happened One Night* and *San Francisco*, was a 35-year-old heartthrob so revered that "Who do you think you are—Clark Gable?" had become a standard put-down.

By 1937, the duo were inseparable enough to be cited as one of "Hollywood's Unmarried Husbands and Wives" in an article in the movie magazine *Photoplay.* The exposure hastened Gable's divorce from [second wife] Ria, who walked off with a sizable settlement. Free at last, Clark and Carole wed in a tiny ceremony on March 29, 1939—the first day Gable had off from his job playing Rhett in *Gone with the Wind.* Their careers had never been in higher gear, but Gable hated the Hollywood partying that went with fame, so the couple made their home in an elaborately restored farmhouse in then-rural Encino, California.

On January 16, 1942, the idyll ended. Lombard, who had just wrapped her 57th film, *To Be or Not to Be,* was on tour to sell war bonds when the twin-engine DC-3 she was traveling in crashed into a mountain near Las Vegas....

Lombard's death, the first war-related female casualty the U.S. suffered during World War II, was the worst loss her husband ever endured. Gable lived out his life at the couple's Encino home, made 27 more movies and even remarried twice. "But he was never the same," says Esther Williams. "His heart sank a bit."

When Gable died of a heart attack in 1961, his fifth wife, Kay, graciously buried him where he belonged: in L.A.'s Forest Lawn Cemetery, right next to Carole Lombard.

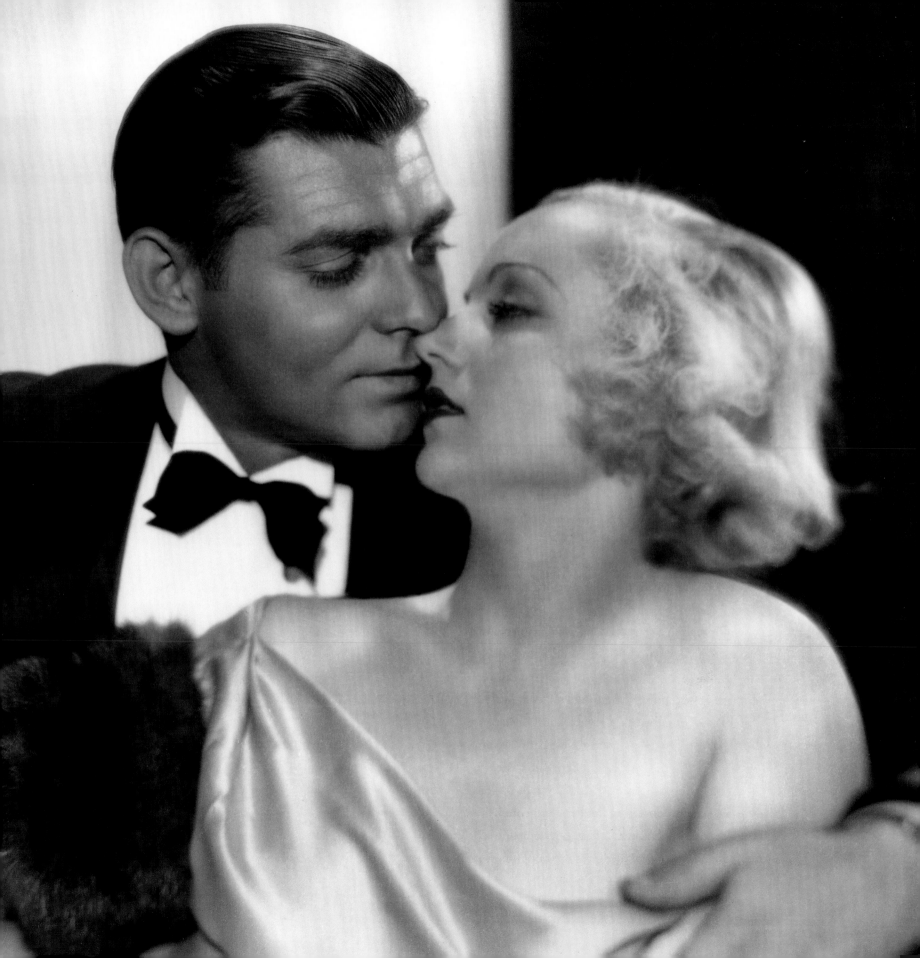

ossie davis & ruby dee

by KHEPHRA BURNS

RUBY DEE AND OSSIE DAVIS. Ossie Davis and Ruby Dee. Their names are linked like heart and soul, like love and marriage, the way Hollywood and substance all too rarely are. Theirs has been a remarkable and richly textured life together that encompasses 46 years of matrimony, two careers, three children, seven grandchildren, numerous campaigns for our social, economic and political equality, and numberless lives influenced through their art and their example.

Ruby and Ossie have said they belong as much to the struggle as to each other. Belonging is one of their favorite themes, and they firmly believe that belonging to Black people, to marches and pickets and kids, is one of the greatest things in the world for a marriage; that the life and health of the family is, in fact, inextricably tied to the life and health of the community.

As veterans of the stage and screen both large and small, they have appeared together in such ground-breaking productions as Lorraine Hansberry's *A Raisin in the Sun* (stage), the plays *Purlie Victorious* (which Davis wrote and directed) and *Take It From the Top* (which Dee wrote and directed), Spike Lee's *Jungle Fever* and *Do the Right Thing*, and Alex Haley's *Roots: The Next Generation.*

Few know that it was Ruby Dee who brought together producer David Wolper and author Alex Haley for the making of the television epic *Roots.* Fewer still know that the roots of Ruby and Ossie's political activism reach back to the 1950s, when they took a strong political stance in their work in defiance of the Communist witch-hunters of the Joseph McCarthy era.

Throughout, their careers have remained a marriage of art and activism. They knew Malcolm X and Martin Luther King, Jr., A. Philip Randolph, Paul Robeson and W.E.B. DuBois. And they boldly supported, marched with, opened their home to and even put their lives on the line for these Black men. It was Ossie Davis who eulogized Malcolm X at his funeral, even in the face of threats of bombs and bullets, and crowned him once and for all our "Shining Black Prince."

Dee and Davis first met in New York City in 1946 at rehearsals for a play called *Jeb.* And it was laughter, not love, at first sight. Ossie remembers Ruby as having long plaits and big inquisitive eyes. Ruby remembers that she often made fun of Ossie because his clothes—procured from a second-hand store—were way too big for him. She was sure the producers had pulled him from behind a plow somewhere. Ossie was so country that when Ruby and the other actors laughed at him, he laughed, too. Nearly half a century later, Ruby and Ossie still laugh a lot—at each other, at their own mad passions and life's stupidities—and credit this sense of humor with helping to make their marriage work.

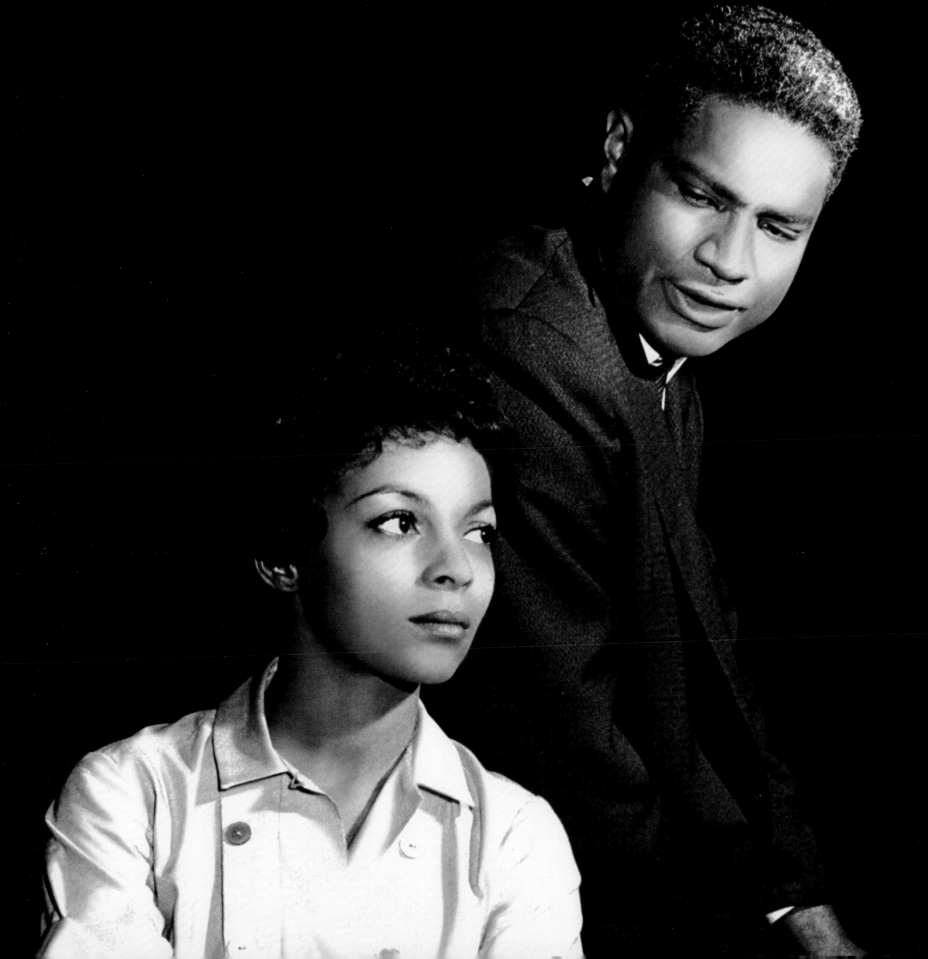

spencer tracy & katharine hepburn

by KATHARINE HEPBURN

NOW I'M GOING TO TELL YOU about Spencer. You may think you've waited a long time. But let's face it, so did I. I was thirty-three. It seems to me I discovered what "I love you" really means. It means I put you and your interests and your comfort ahead of my own interests and my own comfort because I love you. What does this mean? I love you. What does this mean? Think. We use this expression very carelessly.

LOVE has nothing to do with what you are expecting to get—only with what you are expecting to give— which is everything. What you will receive in return varies. But it really has no connection with what you give. You give because you love and you cannot help giving. If you are lucky, you may be loved back. That is delicious but it does not necessarily happen. It really implies total devotion. And total is all-encompassing—the good of you, the bad of you. I am aware that I must include the bad.

I loved Spencer Tracy. He and his interests and his demands came first. This was not easy for me because I was definitely a *me me me* person. It was a unique feeling that I had for S.T. I would have done anything for him. My feelings—how can you describe them?—the door between us was always open. There were no reservations of any kind. He didn't like this or that. I changed this and that. They might be qualities which I personally valued. It did not matter. I changed them.

People have asked me what was it about Spence that made me stay with him for nearly thirty years. And this is somehow impossible for me to answer. I honestly don't know. I can only say that I could never have left him. He was there—I was his. I wanted him to be happy—safe—comfortable. I liked to wait on him—listen to him—feed him—talk to him—work for him. I tried not to disturb him—irritate him—bother him—worry him, nag him. I struggled to change all the qualities which I felt he didn't like. Some of them which I thought were my best I thought he found irksome. I removed them, squelched them as far as I was able. . . .

What was it? I found him—totally—totally—total! I really liked him—deep down—and I wanted him to be happy. I don't think that he was very happy. I don't mean that he did anything or said anything which would indi-cate that he was. How can I say—well, who is happy?—I am happy. I have a happy nature—I like the rain—I like the sun—the heat—the cold—the mountains, the sea—the flowers, the— Well, I like life and I've been so lucky. Why shouldn't I be happy? I don't lock doors. I don't hold grudges. Really the only thing I'm not mad about is wind. I find it disturbing. I mean wind in the heavens. . . .

I have no idea how Spence felt about me. I can only say I think that if he hadn't liked me he wouldn't have hung around. As simple as that. He wouldn't talk about it and I didn't talk about it. We just passed twenty-seven years together in what was to me absolute bliss. It is called LOVE.

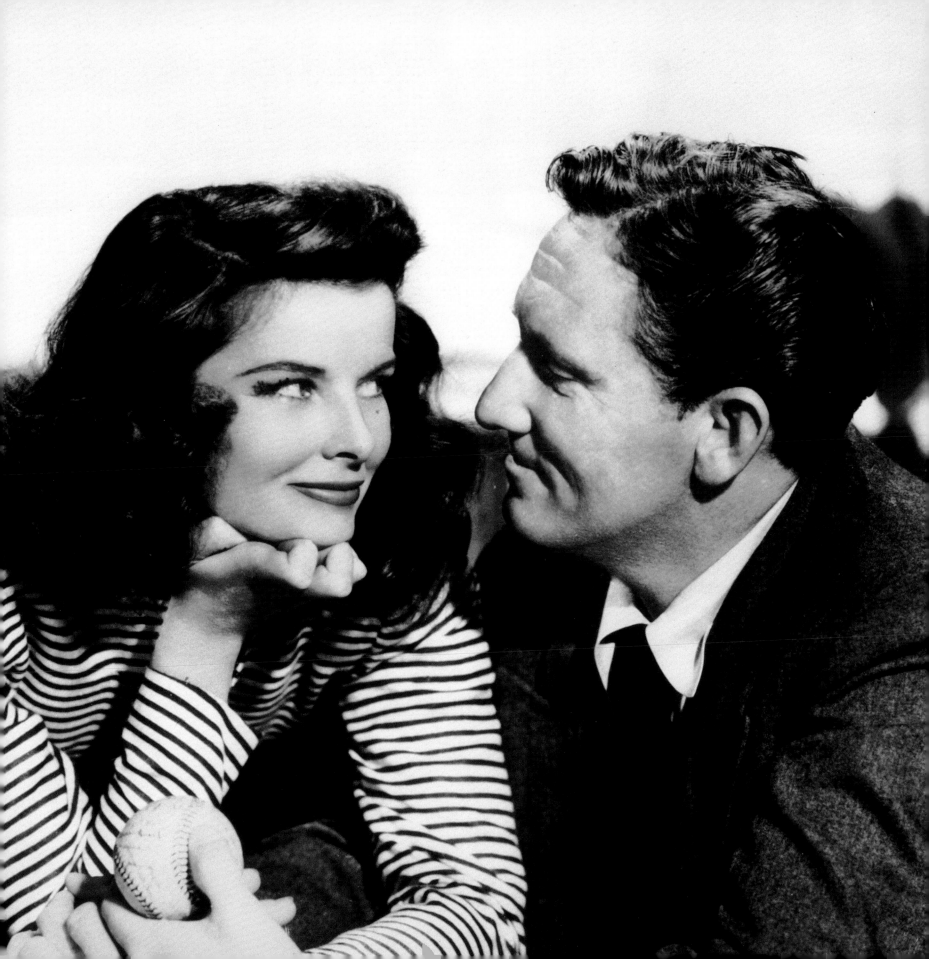

martin luther king, jr. & coretta scott king

by STEPHEN B. OATES

MARTIN LUTHER KING was bored with bachelor life. If the right woman came along, he might like to settle down. One day he was having lunch with a married friend named Mary Powell. "Mary," he said, "I am about to get cynical. I have met quite a few girls here, but none that I am particularly fond of. Do you know any nice, attractive young ladies?"

"Coretta Scott," Mary said. "She is really a nice girl—pretty and intelligent." Mary paused. "But I don't think Coretta is really right for you. She doesn't attend church very often."

He phoned her on a cold February evening in 1952. "This is M.L. King, Jr.," he announced. There was an embarrassing silence on the other end. "A mutual friend of ours told me about you and gave me your telephone number," King went on. "She said some very wonderful things about you and I'd like very much to meet you and talk to you."

"Oh yes"—now she remembered—"I've heard some very nice things about you, also." She had heard some bad things, too, like the fact that he was a Baptist preacher. She thought preachers were all pious stuffed shirts. Still, M.L. didn't sound like some narrow fundamentalist on the phone. In fact, he was smooth and easy. In fact, she had never heard anybody talk like him in her life. "You know every Napoleon has his Waterloo," King drawled. "I am like Napoleon at Waterloo before your charms." Coretta tutted, "Why that's absurd. You haven't seen me yet."

King was unflappable. "Your reputation has preceded you," he said. "I'd like to meet you and talk some more. Perhaps we could have lunch tomorrow or something like that." She said she was free between classes from twelve to one. "I'll come over and pick you up," he said. "I have a green Chevy that usually takes ten minutes to make the trip from Boston University, but tomorrow I'll do it in seven."

They had lunch in a cafeteria, with a cold rain falling outside.... On the way back, he fell silent. Then: "Do you know what?" He looked at her. "You have everything I have ever wanted in a wife. There are only four things and you have them all . . . character, intelligence, personality and beauty."

After that he pursued her aggressively ("not that I ran very hard"). He drove her out to the shore to buy clams and walk along the ocean with its lapping waves and cawing gulls. He took her to the Boston Symphony Hall to hear Arthur Rubinstein perform his magic on the piano.

He talked about preaching—he preached some in area churches—and about how much he wanted to help humanity. Then he got around to the Atlanta girl his father intended him to marry. "But I am going to make my own decisions," he said. "I will choose my own wife." And his choice, he said was her. Would she marry him?

And so it was decided: she would marry Martin and let her career "take care of itself." But you realize, her sister told her, "you will not be marrying any ordinary young minister."

george burns &
gracie allen

by GEORGE BURNS

FOR FORTY YEARS MY ACT consisted of one joke. And then she died. Her real name was Grace Ethel Cecile Rosalie Allen. Gracie Allen. But for those forty years audiences in small-time and big-time vaudeville houses and movie theaters and at home listening to their radios or watching television knew her, and loved her, simply as Gracie. Just Gracie. She was on a first-name basis with America. Lovable, confused Gracie, whose Uncle Barnum Allen had the water drained from his swimming pool before diving one hundred feet into it because he knew how to dive but didn't know how to swim, and who once claimed to have grown grapefruits that were so big it took only eight of them to make a dozen, Gracie, who confessed to cheating on her driver's test by copying from the car in front of her, who decided that horses must be deaf because she saw so few of them at concerts, who admitted making ice cubes with hot water so she would be prepared in case the water heater broke, and who realized it was much better for a quiz show contestant to know the questions beforehand rather than the answers because, "The people who know the answers come and go, but the man who asks the questions comes back every week." Just Gracie, who stated with absolute certainty, "I've got so many brains I haven't used some of them yet...."

Gracie was a beautiful, elegant lady with real style and class. You never saw Gracie looking anything but perfect. And she was charming. And she was very smart, smart enough to become the dumbest woman in show-business history.... We were together day and night for forty years and she never stopped amazing me. She was just a tiny little thing, barely five feet tall and never more than one hundred pounds, but she was capable of so much. Gracie was just as comfortable discussing fancy dresses with the top designers in the world, dining with Al Capone at his place in Chicago, and playing jacks on the kitchen table with the kids as she was serving as the first Mistress of Ceremonies at the Palace Theatre on Broadway—during which she asked the audience, "If I say the right thing, please forgive me," launching National Donut Week by pushing a button to start donut-making machines across the country, dancing on screen with Fred Astaire or running for President of the United States on the Surprise Party ticket.

Gracie was my partner in our act, my best friend, my wife and my lover, and the mother of our two children. We were a team, both on and off the stage. Our relationship was simple, I fed her the straight lines and she fed me. She made me famous as the only man in America who could get a laugh by complaining, "My wife understands me."

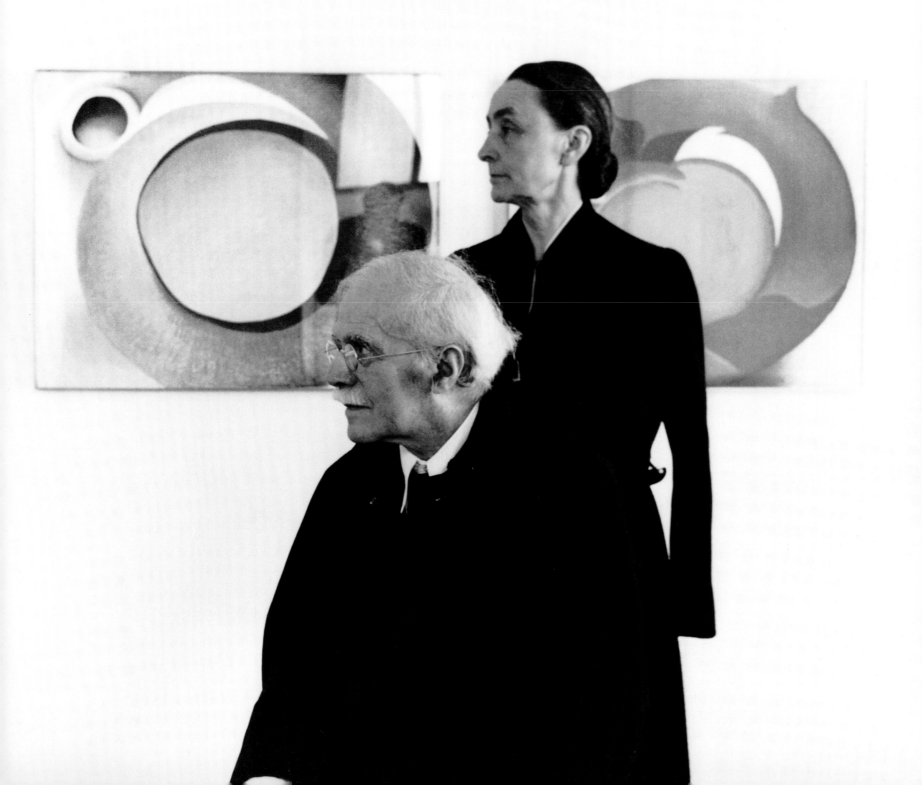

alfred stieglitz &
georgia o'keeffe

by BRENDA CULLERTON

"ART IS A WICKED THING. It is what we are." So scrawled Georgia O'Keeffe on the back of an envelope containing the vitriolic letters written by Alfred Stieglitz to his wife, daughter and brother-in-law during the first year of their own "courtship." Whether meant as explanation, expiation or a last cynical laugh, this epitaph sums up the way O'Keeffe and Stieglitz were: infantile, brilliant, narcissistic, cruel and, yes, at times, even wicked.

He, in 1916, was 24 years her senior, already one of New York's most celebrated and controversial figures. As the man behind a revolutionary movement in photography that became housed in the Little Galleries of the Photo-Secession at 291 Fifth Avenue, Alfred Stieglitz was the son of rich German Jews and accustomed to all the comforts of a bourgeois home. Married (albeit miserably) and surrounded by adoring minions—not to mention the occasional servant—he could never adjust to the gypsy existence that would plague them (and please her) in years to come....

"Whenever I take a picture, I make love," boasted Stieglitz to friends. Make love and photograph he did! In the first two years of their affair, years that blew apart Stieglitz's marriage to wife Emmeline and left daughter Kitty not simply estranged but slightly mad, Stieglitz shot nearly 200 of a lifetime total of 500 O'Keeffe images. Stieglitz's pictures of Georgia—more specifically, of her body parts, of her breasts, her vagina, her feet and hands—stand forever as testament to their mutual possession.

Stieglitz pursued a notorious dalliance with manager and muse Dorothy Norman. The mistress of his "house," of galleries like the famous American Place, Dorothy Norman would inspire an almost unforgivable act of betrayal. It was an exhibition at the Place, in which Stieglitz's photographs of an aging O'Keeffe hung next to those of the voluptuous young Norman. In the eyes of O'Keeffe and others, the show amounted to nothing less than a public hanging. Stieglitz's exposure of their private lives drove O'Keeffe into a depression that imploded into a full-blown breakdown. Only her slow convalescence in a New York hospital...brought her back to life and painting. With a vengeance, of course. She outlived Stieglitz by 40 years, a vital, productive artist.

In 1946, when Stieglitz was discovered in the hallway between his and O'Keeffe's 54th Street bedrooms, felled by a stroke from which he would never regain consciousness, he clutched a pen in his hand. He had been writing to O'Keeffe at Ghost Ranch, her new retreat outside Taos. Right to the end, it was these letters that kept the two artists so closely in touch, from the distance that seemed to suit them. But the letters allow us...to hear their voices, to bridge the distance of their work and stillness of time. As such, the letters are as much a part of the O'Keeffe and Stieglitz legacy as their art.

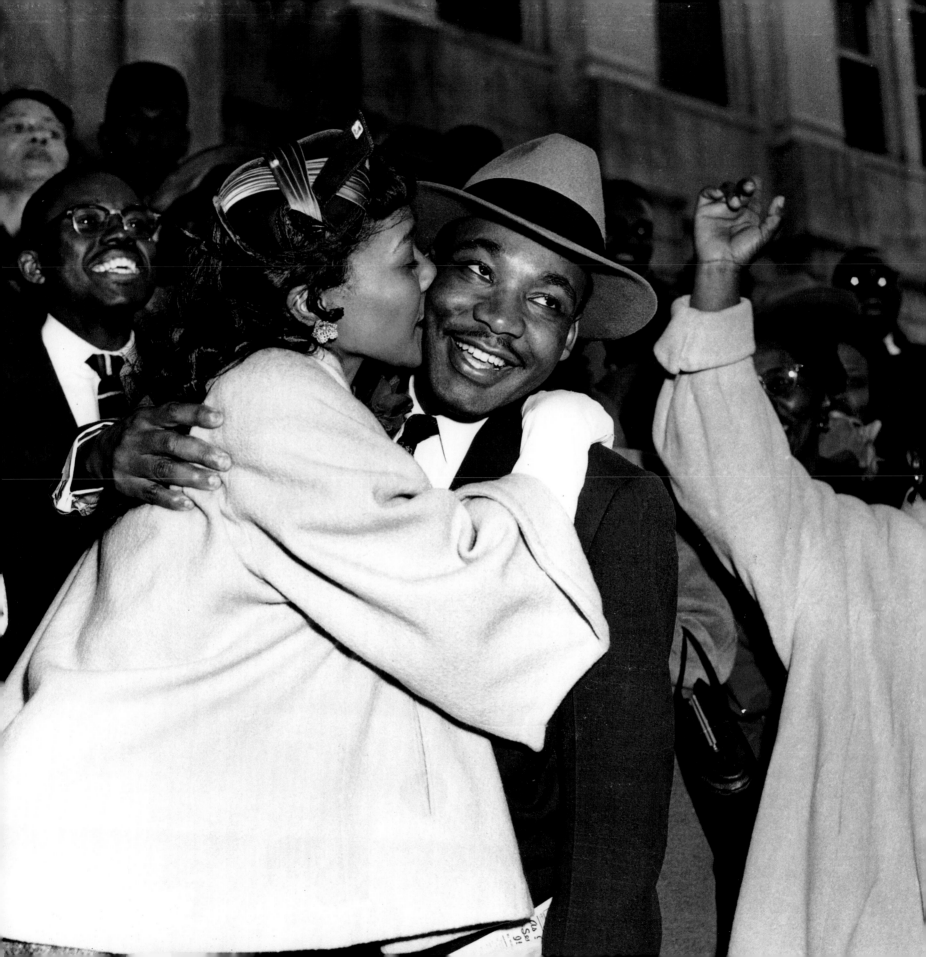

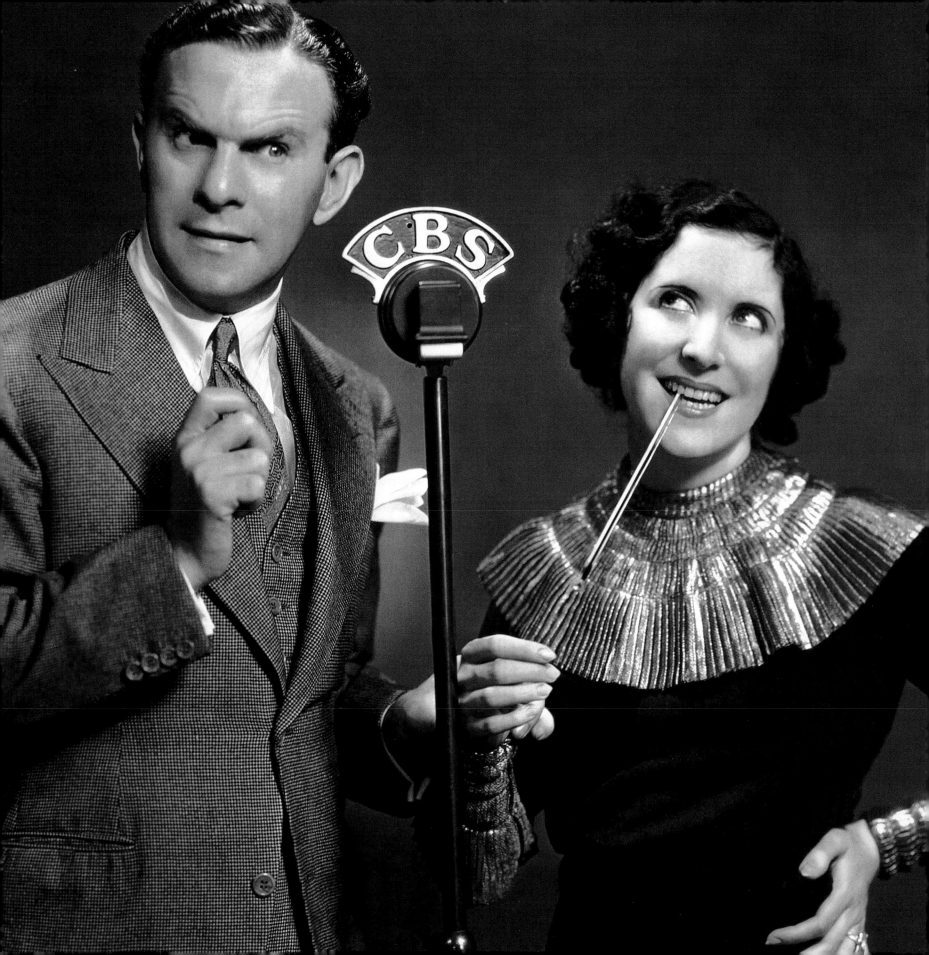

christopher isherwood & w.h. auden

by ELAINE COOPER

CHRISTOPHER ISHERWOOD and W. H. Auden originally met at St. Edmunds' School in London. But it wasn't until 1925, when Isherwood was a budding novelist and Auden was deep into poetry, that they met again. Now they had much in common and the bond was immediate. Before long, the new friends, along with Stephen Spender and C. Day Lewis, were dubbed London's "moderns." The group became known as much for being inseparable as they did for sharp verse. As Spender put it, "You couldn't pry us apart." The four spent endless hours discussing literary rebellion against the staid old English literary world; yet none of them grew closer than Isherwood and Auden.

It's clear from a description of their first 1925 meeting, that Auden had his eye on Isherwood: "He was expensively but untidily dressed in a chocolate-brown suit which needed pressing, complete with one of the new fashionable double-breasted waistcoats. His coarse woollen socks were tumbled, all anyhow, around his babyishly shapeless ankles. . . ."

For his part, the younger Isherwood admired Auden's rebellious, indiscriminate sexual lifestyle. Both felt that open experimentation in relationships was core to understanding oneself—and to overturning the London literary establishment. As Auden would write later: "Without these prohibitive frontiers, we should never know who we are or what we wanted."

Within a few months, the two were romantically involved. Yet not in any predictable way. As Auden biographer Richard Davenport-Hines described it, "Auden and Isherwood began to have sex together; not in a spirit of romantic passion, but as two men who understood one another well, giving and sharing pleasure, relieving tension and having fun."

Isherwood and Auden became famous for their unceasing amorous activities. One might suspect this to be the core of their relationship, but—even though the attraction remained steady—their bond seems to have been built around an intimacy of ideas. Auden and Isherwood remained tightly intertwined for over fifteen years, building off each other, and turning out history-making books. Isherwood authored several classic novels, including *Berlin Stories,* while Auden grew a reputation as one of the most respected poets in English literary history.

The couple eventually dissolved and Christopher Isherwood went on to have another long-term relationship in Los Angeles. Yet many who knew the two felt that in a certain way, they were always truly dedicated to each other. In 1974, when the great poet died, Isherwood, half a world away, was reported by friends to have been "hopelessly inconsolable."

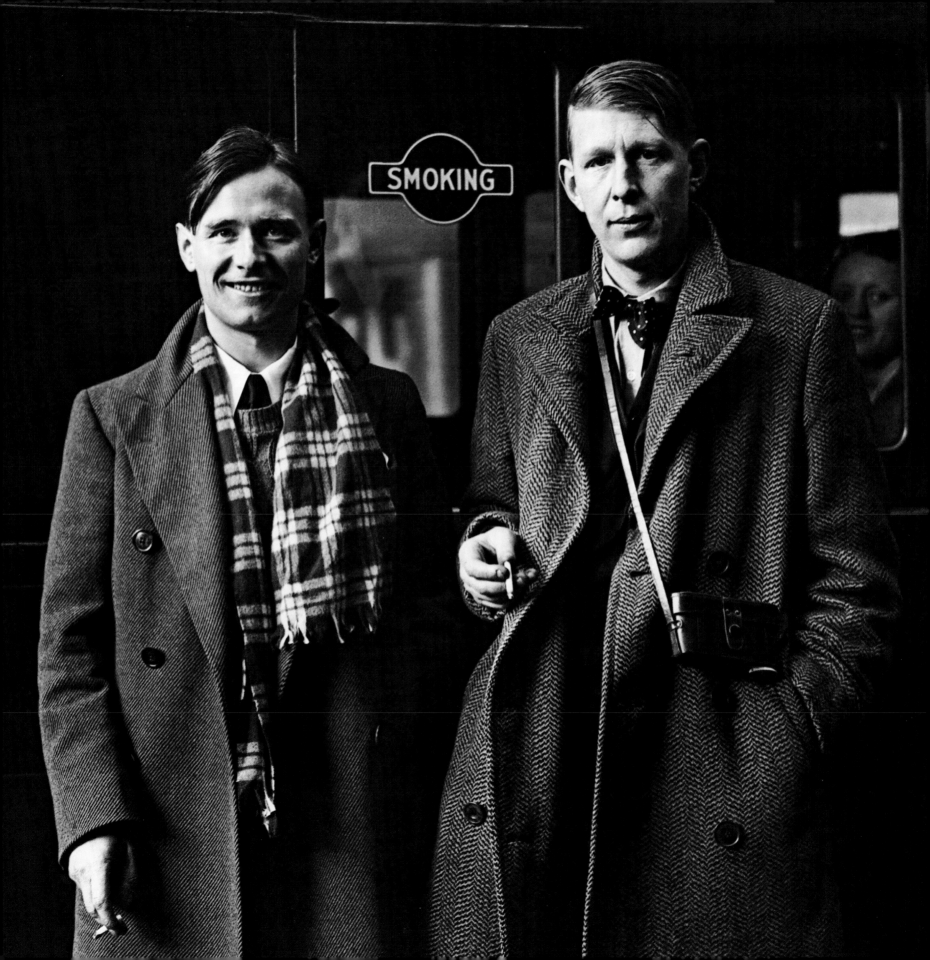

john gregory dunne & joan didion

by JOHN GREGORY DUNNE

WE WERE IN LIKE with each other for a long time before we were in love. Friends for six years but always listening to other voices in other rooms. Being in like gets you through the bad patches when love is strained. But of course we didn't know that then. We met after a drinks party one night when I brought another voice to the one-room basement apartment she was sharing, more or less, with a voice of her own, a close friend until we stopped speaking for whatever reason twenty years later. We had red beans and rice; the woman I was with passed out, and then passed out of my life into marriage, chronic adultery, and divorce in Switzerland. It was years before I spent the night; by then she had graduated to a two-room walk-up on the edge of Spanish Harlem. The bed sagged in the center; it was like falling into a cave.

We got together after I read the galleys of her first novel. We had a celebration lunch at a place on Steak Row. Her other was out of town. It happened. In the ethos of the day, I told her one weekend on Fire Island that we would get married if she got pregnant. She didn't; we decided to get married anyway. Did I ask her or she me? There are moments when we each blame the other. Our engagement was announced on the contributors' page of the *National Review*, where we both freelanced. The day she bought her wedding dress, at Ransohoff's in San Francisco, was the day John Kennedy's motorcade drove into Dealey Plaza in Dallas, past the Texas School Book Depository. The dress had no back; it was incredibly sexy. A few years later, Roman Polanski accidentally spilled a decanter of red wine on it, at a party in Bel Air for Sharon Tate.

She wore sunglasses throughout the service the day we got married, at the little mission church in San Juan Bautista, California; she also wept through the entire ceremony. My younger brother was my best man; he later committed suicide. My four-year-old niece was the flower girl; she was later murdered. As we walked down the aisle, we promised each other that we could get out of this next week and not wait until death did us part. That promise was the bedrock of the marriage. I cannot imagine life without her, the references built up over decades, the quick glances when nothing is said, and volumes are implied. I write this on our twenty-sixth wedding anniversary; she thinks it reasonably discreet. In keeping with our bedrock principle, I don't know if we will make it another year, to twenty-seven, but whatever, it's been a great trip. I remember a day in Paris, high in the Parc des Buttes Chaumont. We are trying to think of an epitaph for our tombstone, and come up with THEY HAD A GOOD TIME. We've had a hell of a good time.

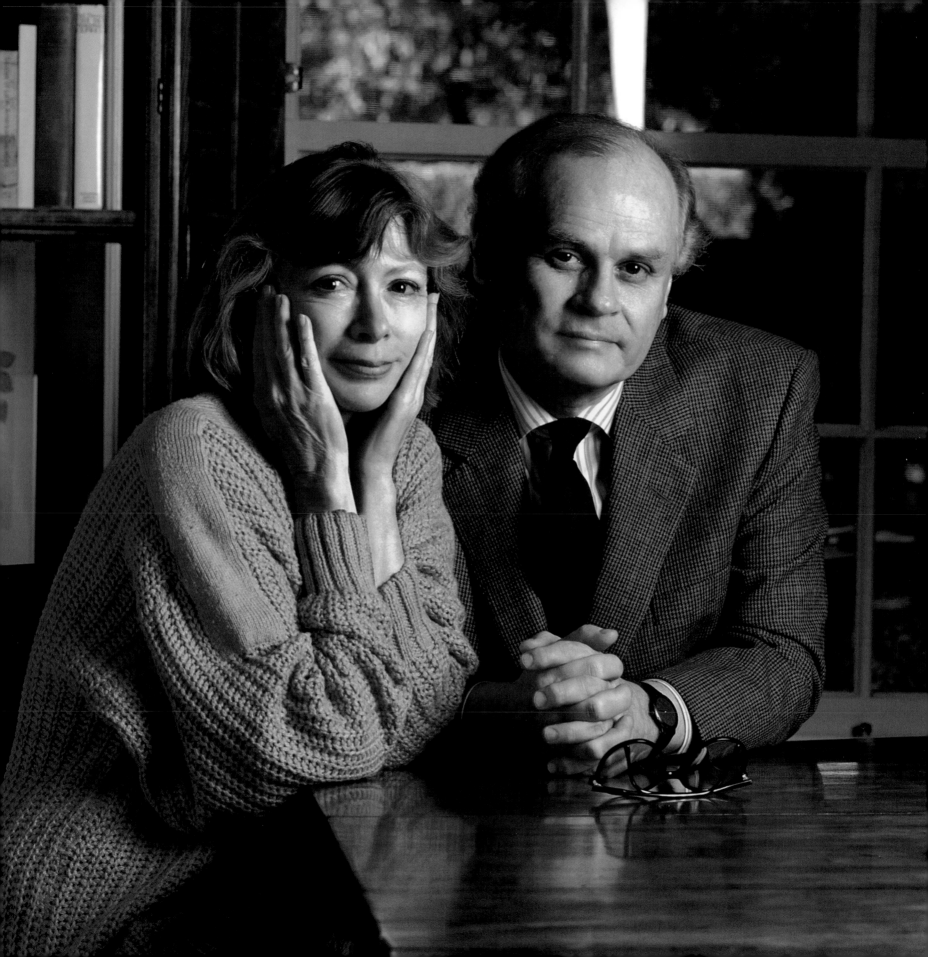

jackie & rachel robinson

by ROGER WILKINS

WHEN JACK ROOSEVELT ROBINSON came up with the Brooklyn Dodgers in 1947, baseball was at the heart of American culture. There were two eight-team major leagues and network radio and few other distractions. The technology and the pace of the country were right for baseball. And so people paid attention. And that was why Jack was so important.

He was right there—in all his splendid, handsome blackness—in the middle of white America's dreams and fantasies, on the ball-field, where there were rules and umpires. White folks could hate him, throw beanballs, spike him, threaten to kill him, spit on him and call him "nigger," "snowflake" and on down. But they couldn't lie about his competence. There were rules and witnesses....

He didn't do it alone, though. There was Branch Rickey, who blended idealism and craftiness and who did a great thing and also stole a march on his fellow owners by being the first to tap a rich pool of talent. And there was Pee Wee Reese, the Dodger captain from Louisville, whose steady decency raised the standards of behavior, first for the Dodgers and then for players all around the National League. But most of all, there was Rachel.

She was not simply the dutiful little wife. She was Jack's co-pioneer. She had to live through the death threats, endure the vile screams of the fans and watch her husband get knocked down by pitch after pitch. And because he was under the strictest discipline not to fight, spike, curse or spit back, she was the one who had to absorb everything he brought home. She was beautiful and wise and replenished his strength and courage.

Together, Rachel and Jack, as beautiful and intelligent an American couple as you'll ever see, walked right into that big white thing that had shackled us all for so long and showed how big a lie it was—right out there with everybody watching. They changed the culture.

They made a lot of white people stop and think and a lot of them began to change their minds. They made a lot of black people stand up straighter, try harder and enjoy life more. It is no coincidence that the Supreme Court ordered the schools desegregated seven years after Jack and Rachel went to the Dodgers or that blacks cracked the back of segregation in Montgomery a couple of years after that.

Jack and Rachel, two heroes. This country owes them more than we can ever even figure out how to say.

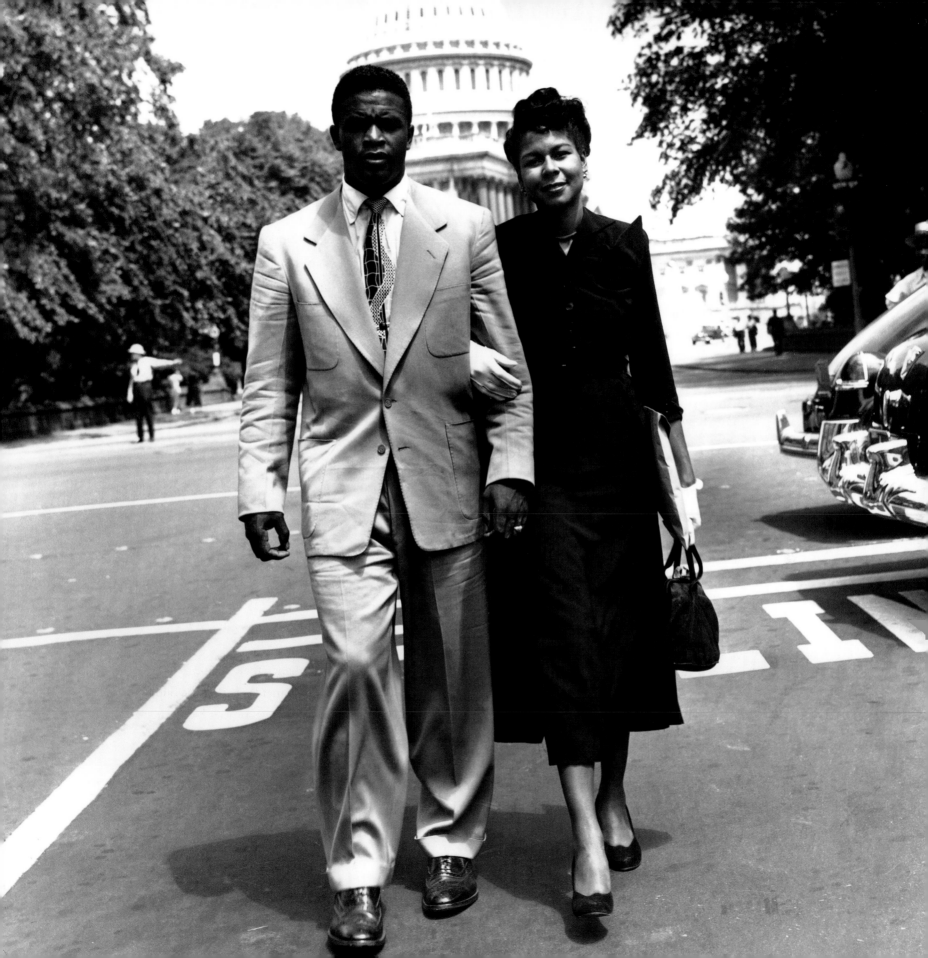

gertrude stein &
alice b. toklas

by SUSAN SCHINDEHETTE

"SHE WAS A GOLDEN BROWN PRESENCE, burned by the Tuscan sun and with a golden glint in her warm brown hair," Alice Babette Toklas wrote in her 1963 memoir about the first glimpse of the love of her life. "She was large and heavy with delicate small hands and a beautifully modeled and unique head." The artistic society of Paris contained many celebrated relationships—Picasso and his succession of quarrelsome mistresses, Scott and Zelda Fitzgerald with their public spats—but none so odd as the lesbian couple of Gertrude Stein and Alice B. Toklas.

They were a striking duo. Both came from well-to-do families; both were raised in California. But they were almost mirror opposites in all else. Stein, a rotund 5'2", favored severe, mannish outfits and wore her hair in a Roman emperor cut. She became a literary lioness for her obtuse prose and career-making opinions, though her books rarely sold well.

Toklas, a slight 5', loved couture clothes (but wore them badly) and championed the career of designer Pierre Balmain, who always sent a car to whisk her to his shows. She had a swarthy complexion and a pronounced mustache, which she refused to shave or pluck. Out for a walk in a *jardin* with their enormous white poodle, the couple were a familiar Paris sight. "They had a childlike side, both of them," recalls artist and acquaintance Jane Eakin, now 73. "They could be silly and play jokes on each other. And they equally loved poking into flea markets."

Perhaps the strangest thing about their relationship, in their circle at least, was its almost Victorian quietude. For 39 years, until Stein's death from cancer in 1946, theirs was a monogamous and proper pairing, a kind of literary mind-meld fused with razor-sharp wit and puritanical behavior. Others might Charleston through the '20s, but in their famous salon at 27 rue de Fleurus, any rare discussion of sexuality did not include the private lives of the hostesses. . . .

Nowhere was their complicated relationship more evident than in 1933's *Autobiography of Alice B. Toklas.* That remarkable book was, of course, written by Stein, because, she joked, "Alice would never get around to it." In the *Autobiography,* Stein abandoned her repetitive prose for a clear and ringing style. At the time, it was the only one of her books to achieve general acclaim.

After Stein's death, Toklas kept her wit and her wits but clearly pined for her companion. Not long before she died, at age 89 in 1967, she returned to Catholicism. "Will this allow me," Alice asked her priest, "to see Gertrude when I die?"

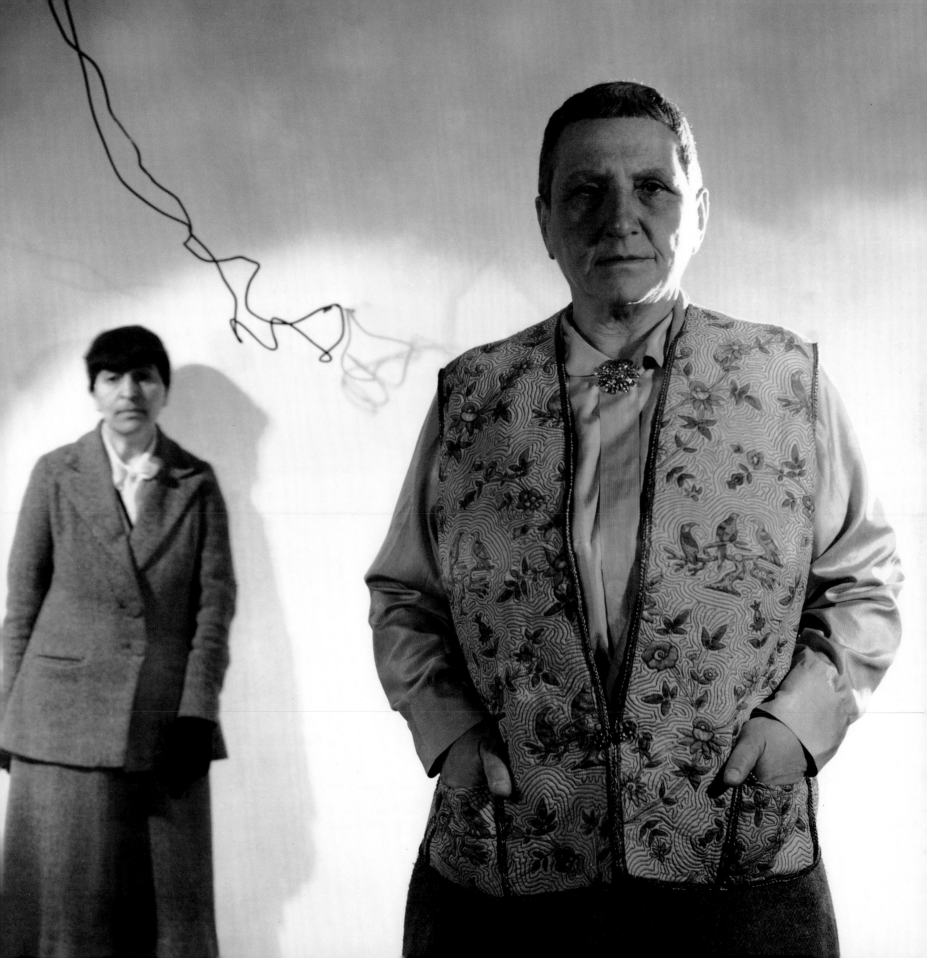

prince philip &
queen elizabeth

by JAMES COLLINS

S HE MAY NOT HAVE SOUNDED quite like the Princess of Wales, but when Queen Elizabeth toasted her husband on the occasion of their 50th wedding anniversary, she did strike a surprising note of intimacy. Talking at one point about the need to be sensitive to the public's will, she said, "I have done my best, with Prince Philip's constant love and help, to interpret it correctly...." There it was—the word love. Yes, she had tucked it away in a parenthetical phrase, but no one could remember the Queen's ever using it in a personal context. Will it now replace "duty" in her lexicon?

Probably not, but during two days of anniversary celebrations, the Queen and Prince Philip displayed exceptional openness and humanity. They spoke of each other and their children with far more feeling than they have in the past.

Did the tone of the anniversary celebrations signal a dramatic change in strategy for the royal family? No. It has been evolving in the direction of more openness for years. Indeed, the Queen invented the "walkabout" early in her reign, and she sees more ordinary people on a regular basis than do most Cabinet ministers and newspaper editors. In 1992 she began paying taxes and reduced the number of royals who receive state funds and the *annus horribilis* speech itself was a notable instance of candor. Nevertheless, the election of [Tony] Blair and the death of [Princess] Diana have intensified the process of bringing the royals closer to the people.

"I think the main lesson we have learnt," Prince Philip said, "is that tolerance is the one essential ingredient in any happy marriage.... You can take it from me, the Queen has the quality of tolerance in abundance."

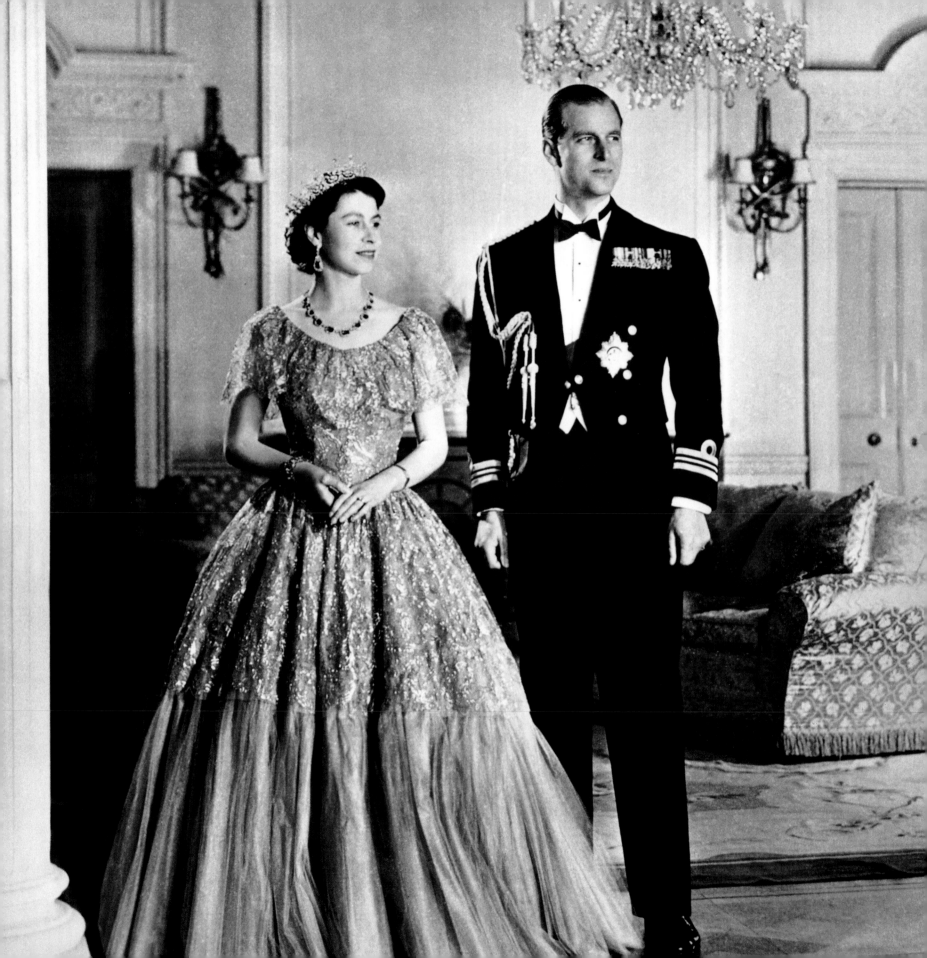

jean paul sartre & simone de beauvoir

by DEIRDRE BAIR

I T SEEMED AS IF THERE WERE not enough hours in a day to contain the rush of ideas they wanted—actually, needed—to share with each other. Sartre gave Simone de Beauvoir something no one, not even her sister, had ever given her before—his undivided attention. This resulted in "talk about all kinds of things but especially about a subject which interested me above all others: myself."

Happily for de Beauvoir, Sartre was different: "Whenever other people made attempts to analyze me, they did so from the standpoint of their own little worlds...Sartre always tried to see me as part of my own scheme of things, to understand me in the light of my own set of values and attitudes." Sartre's description of himself supports hers: "I didn't interest myself at all. I was curious about ideas and the world and other people's hearts."

Also, equally—and perhaps even more importantly—from the beginning their passion was primarily verbal. "Perhaps," Simone de Beauvoir mused in 1986 only weeks before her death, "that was why it lasted so long."

They strode through Paris confidently: de Beauvoir, flushed and happy to be with "the genius who opened the world to me"; the tiny, ugly Sartre, pleased with the robust beauty at his side. They invented scenarios and constructed private fantasy lives, sometimes pretending they were "Mr. and Mrs. Morgan Hattick, the American millionaire and his wife," or "Monsieur and Madame M. Organitique," when they played their game slightly closer to their real French identity.... They spent most of the daylight hours walking the streets awaiting darkness, or, when their passions grew unmanageable, finding some hidden place along country roads where they could have sex. Going to bed with a man in the daytime, especially in a hotel, was out of the question. "Good girls," [de Beauvoir] said in 1982, "did not engage in such behavior...."

He was her mentor, guiding her intellectual life by sending lists of books he wanted her to read so they could discuss them together. He was her lover, and, whatever the actuality of their physical relationship, this romantic attachment had become the primary obsession of her life.... All the same, his dependency on her was just as deep and all-encompassing. He tried to explain it in a letter he wrote while on military service:

> ...it's only to you that I can say what I think, what I want to write, and only you can understand [the frequent mood swings in] my daily state, the constant smoke and fire of ideas.... I know that you are still the only one who can understand me because you are also Mademoiselle Simone de Bertrand de Beauvoir, the brilliant university graduate.

So Sartre was the prince she had always dreamed of, who had awakened her, the sleeping beauty. Still, life in the palace somehow eluded her. In fairy tales, princesses were not expected to conquer the world but to marry the prince and live happily ever after. In real life, the prince was itching for new adventure and growing impatient with the princess, who only wanted to get inside the castle and stay there.

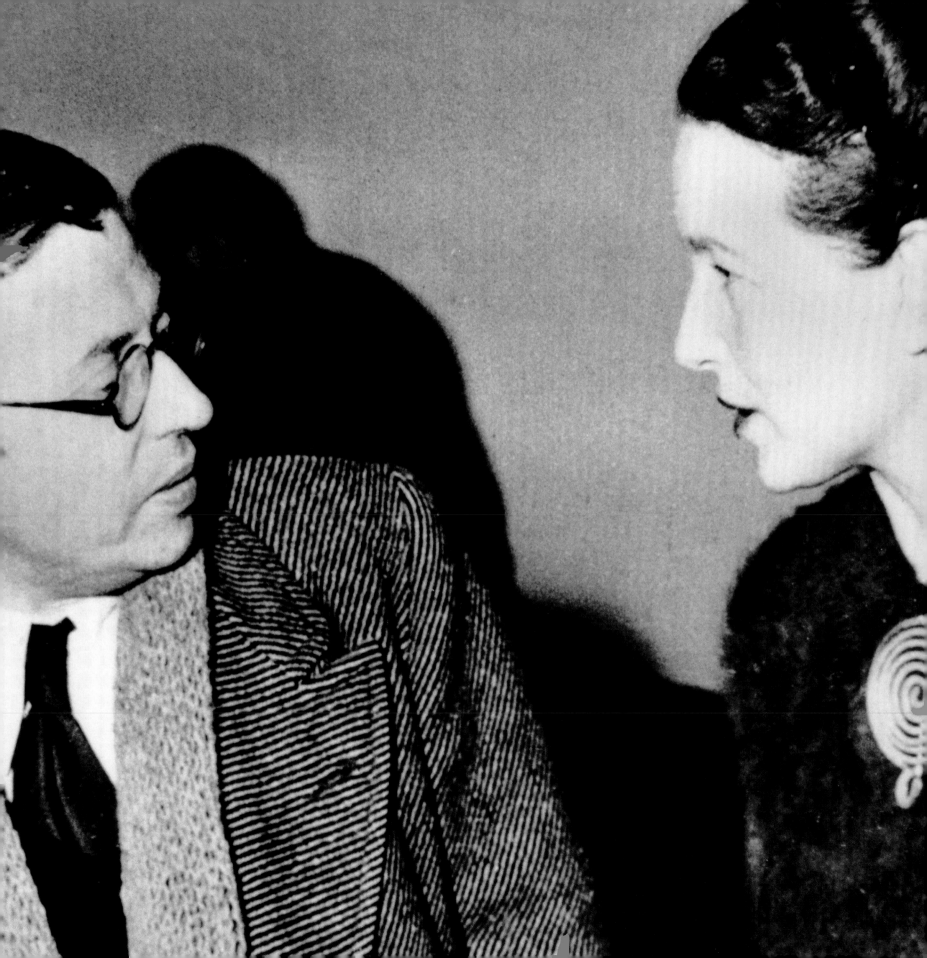

fred astaire & ginger rogers

by LARRY STEVENS

BECAUSE FRED ASTAIRE'S WIFE, Phyllis, was opposed to him kissing another woman, even on the screen, he only kissed Ginger in the film *Carefree*. However, in 1942, at the end of the film *You Were Never Lovelier,* Fred planted a long kiss on the lips of the beautiful Rita Hayworth. The next year, he kissed Joan Leslie in *The Sky's the Limit.* Perhaps Astaire's wife relented after he broke up with Rogers. Or, maybe she just didn't like Fred kissing Ginger Rogers.

Said noted dance critic Arlene Croce: "In their movies, dancing was transformed into a vehicle of serious emotion between a man and a woman. It never happened again...Astaire has had some good dancing partners, but without Rogers it is a world of sun without a moon."

Ginger once said, "I did everything Fred did, only backwards and in high heels."

Katharine Hepburn summed it up most succinctly: "Fred gave Ginger class—Ginger gave Fred sex."

Fred and Ginger met in 1933 when she had the ingenue lead in the Broadway musical *Girl Crazy.* During rehearsals, the producers sensed something was amiss with a production number set to "Embraceable You." They called in Astaire to doctor the choreography. The moment Fred took Ginger in his arms to demonstrate a step, a bystander exclaimed, "They danced on gossamer wings of incredible beauty." The show became a hit and the production number received rave reviews.

Astaire and Rogers next met [later] in 1933, when RKO teamed them in the musical *Flying Down to Rio.* Although they played second leads, they immediately became Hollywood's dancing darlings. During the following years they made ten musicals, nine for RKO. Although most of the plots were less than memorable, their dancing was sublime. They became the most famous dance team the world has ever known.

Distinguished composers such as George Gershwin, Irving Berlin, and Cole Porter vied to write music for their films. Who could ever forget such lilting melodies as "Cheek to Cheek," "The Continental," "Shall We Dance?" "Night and Day," "The Way You Look Tonight" and "They Can't Take That Away From Me." If Fred and Ginger sang and danced to their songs, they were certain to be hits.

Married five times, none of Rogers's marriages lasted more than five years. Perhaps Rogers' most successful "marriage" was with Astaire. It lasted sixteen years.

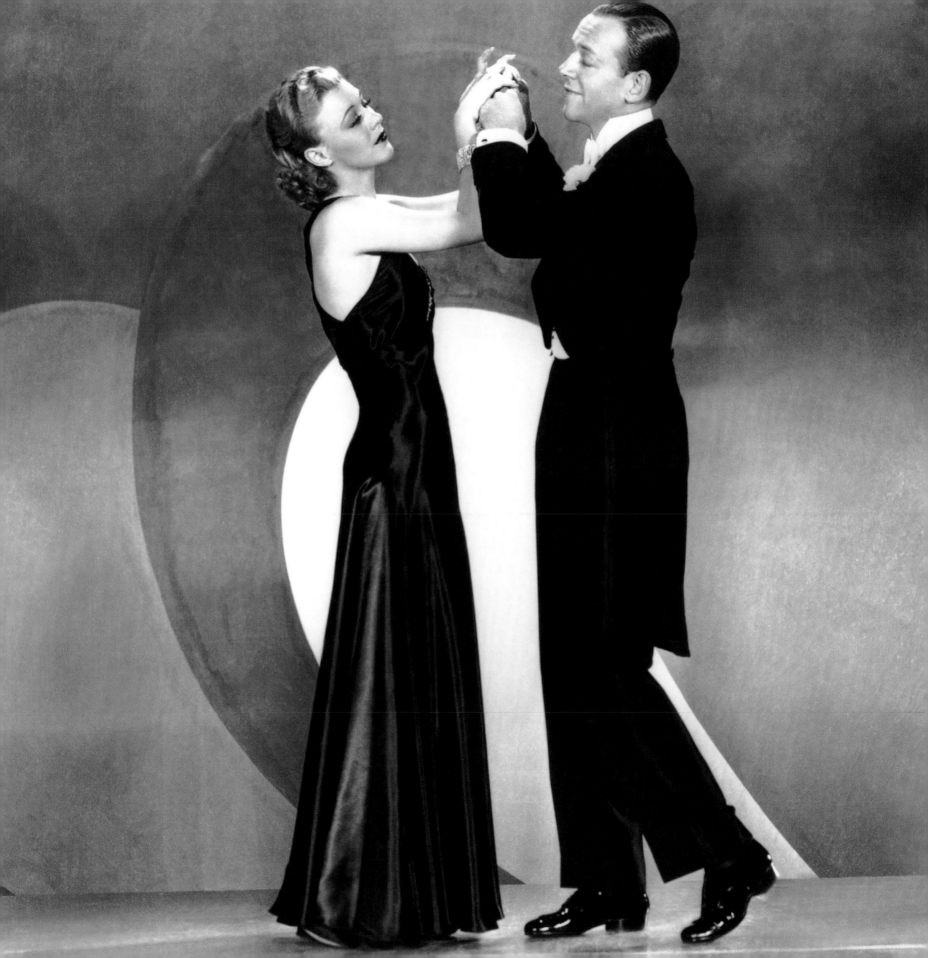

sonny & cher

by HILARY DE VRIES

IT'S NOT LIKE SHE'S MOM—not in the apple-pie, God's-in-his-heaven sense of the word, anyway. She is Cher, after all, with enough incarnations in her long, tattooed, Bob Mackied life to have been dubbed "The Cat" back in her early Vegas days. But when the phone call came, the 52-year-old singer and Oscar-winning actress was above all a mother.

"It was one of those calls where you figure either something's really wrong or the kids want to use the car for the weekend," says Cher, recalling that January day when she learned of the death of her former husband and partner, Sonny Bono, 62, in a ski accident. "And then my daughter said, 'Mom, Dad's dead.'"

"At first I was really being like, 'Oh, sweetheart, I'm so sorry'—you know, trying to comfort her," Cher says during her first full-length interview since Bono's death. "And then I just became hysterical."

At Bono's funeral, attended by, among others, House Speaker Newt Gingrich and former President Gerald Ford, Cher gave an eloquent, funny, poignant eulogy that reminded audiences not only of her ex-husband's remarkable career—during which he went from struggling songwriter to *Sonny and Cher* to U.S. representative—but of his impact on her own singular life.

"I must have written 100 pages and torn them up," she recalls, "and when I finally got up there, I didn't have my glasses, so I had to wing it. But there were so many things I wanted to say." She adds that "though we hadn't spoken in two years, there was a bond that neither one of us could break. We weren't even friendly, but we were more than friends, you know?"

Married from 1964 to 1975, the couple became known as much for Cher's garish, navel-baring costumes and sardonic put-downs of Bono as for such Top Ten hits as "I Got You Babe" and "The Beat Goes On." The two helped usher '60s pop culture to the mainstream through their TV variety show, *The Sonny and Cher Comedy Hour,* which was an unexpected hit in 1971....

"I was with Sonny from [age] 16 to 27," she says, adding that despite their breakup and subsequent spouses, they remained "family."

"Sonny used to piss me off so much," Cher says, launching into a tale about how "he once tried to scam $30,000 off me, and when I found out, I just said, 'That is so you,' and we both started laughing. It just didn't matter." She smiles. "It's like that special place you reserve for a family member: You cut them so much slack because you really like them."

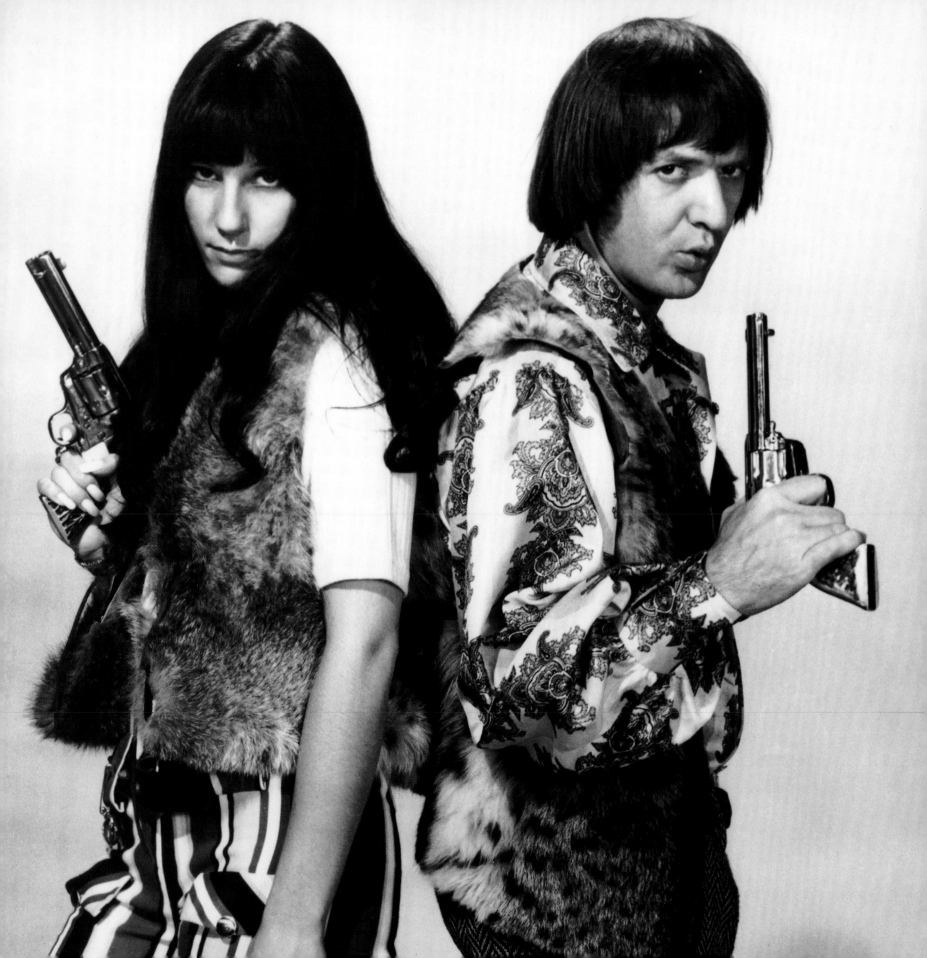

muhammad &
lonnie ali

by TESSA PARKER

THE BLINDING SPEED HAS DIMINISHED, but Muhammad Ali has eased into midlife with the same style and class he used to move about the boxing ring. Once all mouth and fists, Ali's was for a time the most recognizable face on earth. His skill as a boxer, his shameless braggadocio (backed up by the uncanny ability to deliver what he promised), and his physical beauty would probably have been enough to catapult him into the spotlight, but his stance against the Viet Nam War and his religious honesty made him a champion to many outside the ring as well.

One of those people was a shy young neighbor of Ali's family in Louisville, Kentucky named Yolanda "Lonnie" Williams. Lonnie remembers Ali coming home in his huge tour bus when she was seven and he was twenty-two and driving the neighborhood kids all over Louisville. She told *People* magazine, "He'd shout out 'Who's the Greatest?' We'd all answer 'You are!' He was a blast." Their friendship grew and eventually, like millions of other young women, she fell in love with Ali, but with one difference: "I always knew that one day I was going to marry Muhammad. I didn't know how, when, or where, but I knew it was going to happen."

When Ali's third marriage to Veronica Porche came to an end, Lonnie gave up her job and flew to be with him. It was a tough time for Ali. Besides the divorce, Parkinson's syndrome—a disease that strikes the nervous system, impeding speech and movement—had set in and he was suffering from depression. "I think I offered Muhammad some kind of stability, somebody that he could always count on to be there, because I had always been there for him and he had always been there for me. So it just occurred naturally," Lonnie told *Ebony* in 1989. "Lonnie is a woman with discernable soft and humorous sides," Peter Richmond wrote. "She is a strong woman who walks through a room like a beautiful storm approaching. But she is also a no-nonsense person. She is running the business of Muhammad Ali."

Today, comforted by his wife and his faith in Islam, Ali is content. When they are not on their 88-acre estate in Berrien Springs, Michigan, the Alis travel the world, donate time and money to charities, and are currently building a cultural center in Louisville.

Parkinson's has slowed the champ physically, but like almost everything else, he and Lonnie look at it as a divine gift. "Parkinson's disease has made him a more spiritual person," Lonnie says. "Muhammad believes God gave it to him to bring him to another level, to create another destiny."

As for Ali, he's simply content to remind the world how pretty he still is.

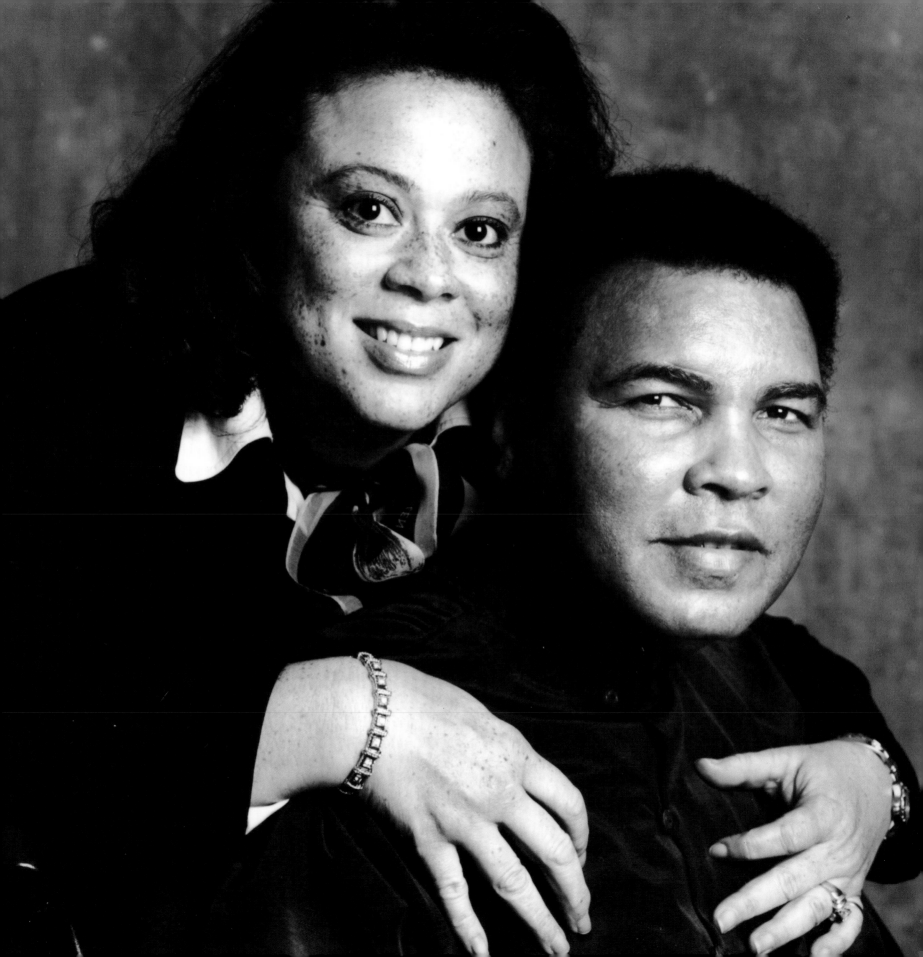

biographies

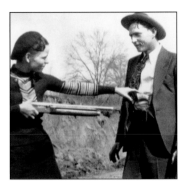

Muhammad & Lonnie Ali first met when Lonnie was five years old. As years went by and Ali accumulated heavyweight championships, the couple became close friends and were eventually married in 1986. But the friendship came first. As Lonnie says, "If two people aren't friends, I don't see how they can be in love." The former champ and Lonnie and their nine children now live on their farm in Berrien Springs, Michigan.

Tessa Parker
is a freelance writer living in New York City.

Photo: NEIL LEIFER

page 110

Desi Arnaz & Lucille Ball first met during the filming of *Too Many Girls* (1940). Lucy, a model, movie actress, and radio personality, became the toast of America with her Cuban band-leader husband in the most popular television show in history, *I Love Lucy.* Together they created Desilu Productions and Lucy grew to become one of the most loved comedians of all time.

Michael J. Neill
is a regular contributor to *People* magazine.

Photo: UPI/CORBIS-BETTMANN

page 72

Fred Astaire &
Ginger Rogers
both began working in vaudeville as children. They first paired up in 1933 for *Flying Down to Rio,* and lit Hollywood on fire. The couple went on to make nine unforgettable films together. After Rogers turned to dramatic roles, Astaire made more dance films, but none matched his magic with Ginger.

Larry Stevens
wrote this piece on Fred and Ginger in 1991.

Photo: CORBIS

page 106

Clyde Barrow &
Bonnie Parker
were partners in crime from Telico, Texas in the early 1930s. The lovers, with the Barrow Gang, committed numerous burglaries and auto thefts until May 1934 when they were trapped and shot during a roadside ambush.

Janet Wellon
is a freelance editor and writer living in San Francisco.

Photo: UPI/CORBIS-BETTMANN

page 50

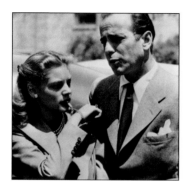

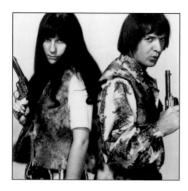

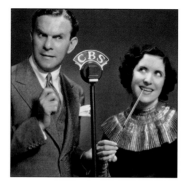

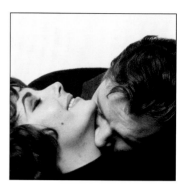

Humphrey Bogart &
Lauren Bacall
starred together in several
movies, including the
classics, *To Have and Have
Not* (1944) and *The Big Sleep*
(1946). They met on the set
of the former and were
married from 1945 until
Bogart's death from cancer
in 1957.

Photo: UPI/CORBIS-BETTMANN

page 12

Sonny Bono &
Cher Sarkisian
In 1964, Bono recorded his
first song with then-girl-
friend Cherilyn Sarkisian,
which was soon followed by a
number of hits including, "I
Got You Babe." *The Sonny
and Cher Show* premiered in
1971, where it remained a
top-rated show until 1974.
Cher went on to a successful
career in music and film.
Bono became mayor of Palm
Springs and a California
Congressman. He died in a
tragic skiing accident in
1998.

Hilary de Vries
writes on actors and enter-
tainers for *TV Guide.*

Photo: SPRINGER/CORBIS

page 108

George Burns &
Gracie Allen
first met while aspiring
to the vaudeville stage.
Burns and Allen had a
tremendously successful
seventeen-year radio career
before moving to Hollywood
in the 1950s for television
and movie careers. Gracie
Allen died of a heart condi-
tion in 1962. Burns never
remarried and continued his
monthly visits to Gracie at
Hollywood's Forest Lawn
Cemetery until his death.

Photo: SUPERSTOCK

page 92

Richard Burton &
Elizabeth Taylor,
the most decadent couple
in Hollywood history, were
married twice, during 1964
and 1974. They appeared
together in *Cleopatra* and
The Taming of the Shrew
during the 1960s. Taylor
received an Academy Award
for her work in the amazing
*Who's Afraid of Virginia
Woolf* with Burton. Richard
Burton died of a brain hem-
orrhage in 1984. Taylor took
on a new role as an advocate
for AIDS sufferers during
the 1980s.

Janet Cawley
is a writer for *People*
magazine.

Photo: BERT STERN

page 32

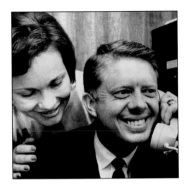

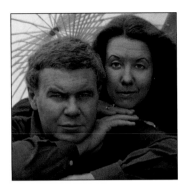

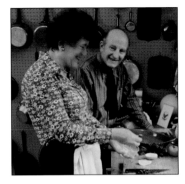

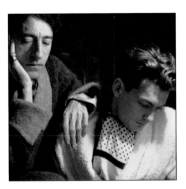

Jimmy & Rosalynn Carter
Jimmy Carter, 39th President of the United States, is perhaps best known for his post-presidency work of international diplomacy. His wife of 50 years, Rosalynn, was an active First Lady, speaking out on human rights and attending cabinet meetings. They continue to work hand in hand on Habitat for Humanity, building houses for the poor.

Photo: UPI/CORBIS-BETTMANN

page **38**

Raymond Carver &
Tess Gallagher
Raymond Carver, the acclaimed short story writer (*Will You Please Be Quiet, Please?* and *What We Talk About When We Talk About Love*) met poet Tess Gallagher in 1978. The soulmates were inseparable in writing—and life—until Carver's sudden death from cancer in 1986.

Photo: MARION ETTLINGER

page **70**

Paul & Julia Child
are known for their work in the culinary arts. After training at Cordon Bleu in Paris, Mrs. Child co-authored the two-volume *Mastering the Art of French Cooking* and hosted several popular television cooking series, which established her as one of the most successful and most parodied celebrity chefs. Her latest book is *The Way to Cook*. Paul Child was a wine expert and writer who passed away in 1992.

Nöel Riley Fitch
is the author of biographies on Sylvia Beach and Anaïs Nin. This excerpt is from the 1998 *An Appetite for Life: A Biography of Julia Child*.

Photo: PETER VANDERMARK

page **68**

Jean Cocteau &
Jean Marais
Cocteau was a novelist, playwright, actor, and filmmaker. Marais, 24 years Cocteau's junior, acted in many of the writer's works, including the plays *Les Chevaliers de la Table Ronde* and *Les Parents Terribles* and the films *Beauty and the Beast* and *Ruy Blas*.

Randall Koral
is the former Executive Editor of *Vogue* and *Elle*. He now lives in Paris, creating websites for the Cannes Film Festival, Yves St. Laurent, and others.

Photo: CECIL BEATON

page **44**

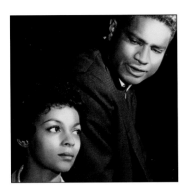 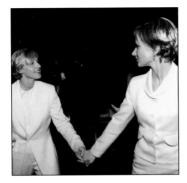 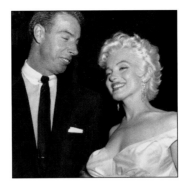

Ossie Davis & Ruby Dee
Stage, film, and television actor Davis is best know for *The Joe Louis Story* (1953) and *Purlie Victorious* (1963), which he wrote, directed— and cast his wife, Ruby Dee. Ruby Dee has appeared in numerous stage and screen roles, including *Roots: The Next Generation* and *Jungle Fever.* They continue to work together as actors and political activists.

Khephra Burns
is a writer for *Essence* magazine.

Photo: ARCHIVE PHOTOS

page 84

Ellen DeGeneres &
Anne Heche
met on the set of *Ellen,* the now-famous television series, in which star DeGeneres "came out of the closet." DeGeneres has worked as a stand-up comedian and movie actress. Heche has appeared in the films *Six Days, Seven Nights, Psycho,* and *Return to Paradise.*

Hilary de Vries
is a writer for *TV Guide.*

Photo: BRIAN K. DIGGS

page 60

Joe DiMaggio &
Marilyn Monroe
were married for nine months in 1954. DiMaggio, the legendary New York Yankee baseball star, and Monroe, the sex-symbol actress (*The Asphalt Jungle, Some Like It Hot, Bus Stop),* continued to be close friends for years after divorce, even planning to remarry before Monroe died tragically (and mysteriously) of an overdose of barbiturates.

Donald Spoto's
biographies include *The Dark Side of Genius: The Life of Alfred Hitchcock, Diana: The Last Year,* and *Marilyn Monroe.*

Photo: UPI/CORBIS-BETTMANN

page 22

John Gregory Dunne &
Joan Didion
have written articles, essays, novels and screenplays. Didion's essays and novels include *A Book of Common Prayer, The White Album,* and *Salvador.* Dunne has published *Harp* and is a frequent contributor to *Esquire* and *Vanity Fair.*

Photo: BLAKE LITTLE

page 96

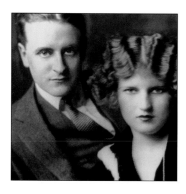

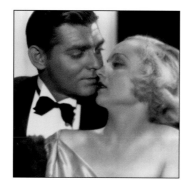

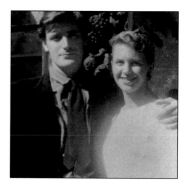

F. Scott & Zelda Fitzgerald met in Montgomery, Alabama, Zelda's hometown, when Scott was stationed there in the army. They lived an extravagant life in New York City and Europe, while Scott wrote *Tender Is the Night* and *The Great Gatsby*. Eventually, Scott turned to Hollywood screenwriting after Zelda was committed to a mental institution for schizophrenia. She remained there until her death in 1948.

Tom Gliatto writes frequently for *People* magazine.

Photo: GEORGE RINEHART

page 14

Clark Gable & Carole Lombard were married for six years. Gable's movies include *Gone With the Wind* (1939) and *It Happened One Night* (1934), for which he received an Oscar. Lombard starred in over 50 films, beginning with *The Girl from Everywhere* (1927) and ending with *To Be or Not to Be* (1942). After Lombard died in a plane crash in 1942, Gable flew Air Force bombing missions during World War II. A heartbroken Gable died in 1961 after filming *The Misfits.*

Sophfronia Scott Gregory is a regular contributor to *People* magazine.

Photo: UPI/CORBIS-BETTMANN

page 82

Dashiell Hammett & Lillian Hellman were prolific writers devoted to political causes. Hammett's hard-boiled fiction includes *Red Dust* (1929) and *The Thin Man* (1934). Hellman is known for her plays *The Little Foxes* (1939) and *Toys in the Attic* (1960). They lived together for more than thirty years.

Richard Lacayo writes for *People* magazine.

Photo: GEORGE KARGER

page 62

Ted Hughes & Sylvia Plath met in England in 1956, married, and had three children. Both were accomplished poets: Plath published *The Bell Jar,* an autobiographical novel and several volumes of poetry (including *Ariel*) while Hughes became Britain's poet laureate and, just before his death, published *Birthday Letters,* a book of poems about his life with Sylvia.

A. Alvarez is a psychologist and writer. He was close friends with Sylvia Plath and has written about her extensively. This excerpt is from his 1998 piece for *The New Yorker.*

Photo: WARREN PLATH

page 66

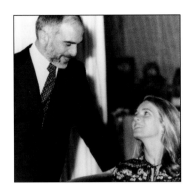

King Hussein & Queen Noor
The King of Jordan & Lisa
Halaby met while Halaby, a
Princeton graduate, was
working for an architectural
firm in Amman. Hussein
died in 1999; he is survived
by his Queen and their four
children.

Dorothy Rompalske
is a regular contributor to
Biography magazine.

Photo: UPI

page 52

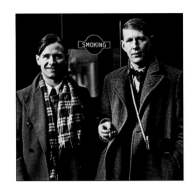

Christopher Isherwood &
W.H. Auden
began collaborating on verse
plays in the 1930s. They
maintained an on-and-off
relationship for the next 30
years, until Isherwood's
death in 1986. Isherwood
was best known for his
novels, *Mr. Norris Changes
Trains* and *Goodbye to Berlin*,
while Auden became one
of the most respected poets
in the history of English
literature.

Elaine Cooper
is a writer and critic living
in London.

Photo: HOWARD CARTER

page 94

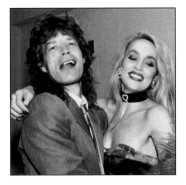

Mick Jagger & Jerry Hall
were married in 1991. After a
long fling with Bryan Ferry,
the supermodel from
Mesquite, Texas lassoed the
notorious Rolling Stones
lead singer. Though their
marriage endured Mick's
numerous rumored dal-
liances for almost eight
years, the couple has
recently decided to divorce.

Karen S. Schneider
is a writer for *People*
magazine.

Photo: SUSAN RAGAN

page 34

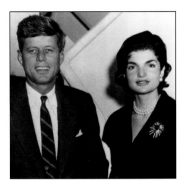

John Kennedy &
Jacqueline Kennedy
were the 35th First Couple
of the United States. John
Kennedy inspired Americans
to seek a better world
through government service.
Jackie became an astonish-
ingly influential fashion
leader, completely restored
the White House and, after
John's assassination, worked
with Viking and Doubleday
publishers as an editor.

Christopher Andersen
is the author of several
biographies, including *The
Day Diana Died* and *Jack
and Jackie: Portrait of an
American Marriage*.

Photo: UPI/CORBIS-BETTMANN

page 18

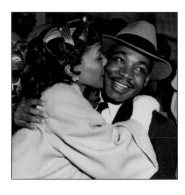 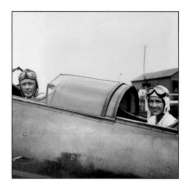 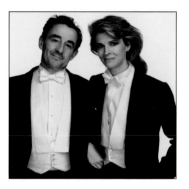

Martin Luther King, Jr. & Coretta Scott King led the Montgomery bus strikes, which initiated the struggle for civil rights. After Martin Luther King, Jr. was assassinated, Coretta continued his legacy of non-violent resistance by rallying for a national holiday in his honor and serving as president of the MLK, Jr. Center for Non-Violent social change.

Stephen B. Oates is the author of numerous biographies, including *Let the Trumpet Sound: A Life of Martin Luther King, Jr.*

Photo: GENE HERRICK

page 88

John Lennon & Yoko Ono first met in 1966 at a gallery exhibit for Yoko in London. John was particularly taken by Yoko's piece where the viewer climbed a ladder to a peephole displaying the word "yes." From then on they remained inseparable, "bedding for peace," and recording several classic albums, including "Double Fantasy" in 1980, the same year Lennon was shot and killed outside his home in New York.

Ray Coleman is the author of *The Man Who Made the Beatles* (about Brian Epstein) and *Lennon: The Definitive Biography.*

Photo: ALAN TANNENBAUM

page 26

Charles & Anne Morrow Lindbergh Charles Lindbergh is known as an aviator, inventor, and environmentalist. He made a series of epic flights during the 1930s, often accompanied by his wife Anne Morrow Lindbergh, an author who wrote *Gift from the Sea*, a collection of essays that continues to be a bestseller.

Laura Muha writes profiles for *Biography* magazine.

Photo: UPI/CORBIS-BETTMANN

page 28

Louis Malle & Candice Bergen The late Louis Malle directed numerous critically acclaimed films. Bergen, a model and actress, is best known for her television series, *Murphy Brown,* on which she gave birth to Chloe, her child with Malle.

Roger Rosenblatt is the author of *Black Fiction,* and *Coming Apart: A Memoir of the Harvard Wars.* His profile of Bergen and Malle was written for *Vanity Fair* in 1992.

Photo: ANNIE LEIBOVITZ

page 80

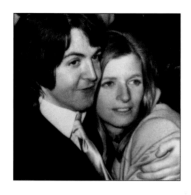

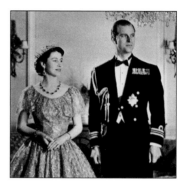

Paul & Linda McCartney were married for 30 years. After the Beatles broke up, lead singer McCartney founded a new band, Wings, with Linda. In addition to their incredibly successful musical careers, the McCartneys worked for animal rights and marketed vegetarian food products. Linda died of cancer in 1998; this excerpt is Paul's statement at her funeral.

Photo: UPI/CORBIS-BETTMANN

page 56

Paul Newman & Joanne Woodward have acted in films since the 1950s. Newman's films include *Cool Hand Luke, Hud,* and *The Color of Money,* for which he received an Academy Award. Woodward's films include *The Three Faces of Eve* and *Rachel, Rachel.* The long-married couple most recently appeared together in *Mr. and Mrs. Bridge*; they regularly work as activists on behalf of political and social causes.

A.E. Hotchner, a close friend of Paul Newman's, has co-written two cookbooks with the actor: *Newman's Own Cookbook* and *The Hole in the Wall Cookbook.*

Photo: UPI/CORBIS-BETTMANN

page 24

Laurence Olivier & Vivien Leigh were two screen legends best known for their roles as Heathcliff in *Wuthering Heights* and Scarlett in *Gone with the Wind,* respectively. They were a revered Hollywood couple for years, until they separated due to Leigh's deteriorating health in the 1950s.

Jesse Lasky, Jr. is the author of *Love Scene: The Story of Laurence Olivier and Vivien Leigh.*

Photo: UPI/CORBIS-BETTMANN

page 58

Prince Philip & Queen Elizabeth Philip, also known as Lt. Philip Mountbatten, married Princess Elizabeth in 1947. In 1956, after Elizabeth became Queen of the United Kingdom, the couple began the Duke of Edinburgh Award to foster challenging activities for young people.

James Collins writes for *Time* magazine.

Photo: SUPERSTOCK

page 102

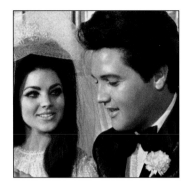

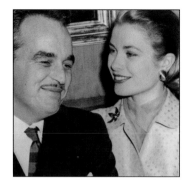

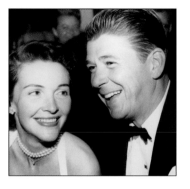

Jackson Pollock &
Lee Krasner
Abstract expressionist
Pollock changed American
painting with his radical
spatter-and-drip technique.
He met painter Krasner in
New York. In 1946, they
moved to Easthampton,
Long Island, where, close
to Krasner, Pollock created
his best work.

Deborah Solomon
writes on the lives of artists.
She is the author of *Utopia
Parkway: The Life and Work
of Joseph Cornell* and *Jackson
Pollock: A Biography*, from
which this excerpt is taken.

Photo: THE SMITHSONIAN
INSTITUTION

page 30

Elvis & Priscilla Presley
started seeing each other
when Priscilla was 14. Soon
the King decided it was time
to marry; they remained so
from 1967-1973. In 1973,
following their divorce,
Presley became drug-depen-
dent and overweight, and he
spent his last years living
reclusively at his Memphis
home, Graceland. After
Elvis's 1977 death, Priscilla
pursued a career in acting.

Kim Hubbard
is a writer for *People*
magazine.

Photo: UPI/CORBIS-BETTMANN

page 40

Prince Rainier &
Grace Kelly
met during the spring of
1955. Grace gave up a career
as a successful Oscar win-
ning actress to become
Princess of Monaco in 1956.
Their marriage ended when
Grace was killed in a car
crash in 1982.

James Spada
is the author of dozens
of biographies, including *The
Divine Bette Midler, Grace:
the Secret Lives of a Princess*,
and most recently, *Streisand:
Her Life.*

Photo: UPI/CORBIS-BETTMANN

page 36

Ronald & Nancy Reagan
were both movie actors
when they married in 1952.
Reagan moved to politics,
eventually becoming 40th
President of the United
States, with Nancy as his
First Lady. Today, she con-
tinues by his side, watching
over him in his fight against
Alzheimer's disease. They
have four children.

Cynthia Sanz
is a regular contributor to
People magazine.

Photo: UPI/CORBIS-BETTMANN

page 78

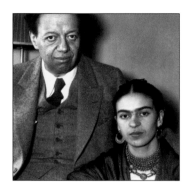

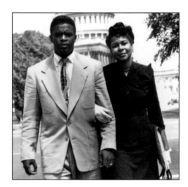

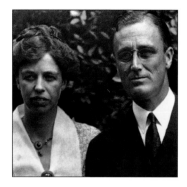

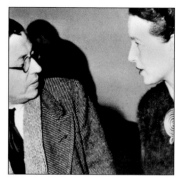

Diego Rivera & Frida Kahlo
first met when Rivera was
commissioned to paint a
mural at Kahlo's high
school. Rivera is known for
his Social Realism painting
style, while Kahlo's paint-
ings include amazing surreal-
istic portraits from her life.
A museum in her honor was
recently established in
Coyoacan, Mexico.

Martha Zamora
met Frida Kahlo as a young
girl. Zamora, who lives in
Mexico City, writes and
speaks extensively on the life
and work of Kahlo.

Photo: UPI/CORBIS-BETTMANN

page 20

Jackie & Rachel Robinson
Jackie Robinson became
the first African-American
baseball player in the major
leagues when he signed with
the Brooklyn Dodgers in
1947. Rachel stood by his
side through civil rights
confrontations and they
worked tirelessly together as
civil rights activists until his
death.

Roger Wilkins
is a regular contributor to
The Nation, from which this
excerpt is taken.

Photo: UPI/CORBIS-BETTMANN

page 98

Franklin & Eleanor
Roosevelt
were married in 1905. In
1933, Franklin became Pres-
ident of the United States,
establishing a radical social
and economic program
known as the "New Deal."
Eleanor became his outspo-
ken First Lady, travelling
around the country and
speaking out for the poor
and racially discriminated.

Doris Kearns Goodwin
is the author of *No Ordinary
Time* and *Lyndon Johnson
and the American Dream*.

Photo: UPI/CORBIS-BETTMANN

page 64

Jean Paul Sartre &
Simone de Beauvoir
met at the Sorbonne in Paris,
where de Beauvoir studied
philosophy under Sartre.
Sartre penned classic books
of existentialism, including
Nausea and *Being and Noth-
ingness*, while de Beauvoir
was responsible for the clas-
sic book on feminism, *The
Second Sex*. They remained
companions until his death
in 1980.

Deirdre Bair
is the author of *Simone de
Beauvoir*.

Photo: THE NEW YORK TIMES
COMPANY/ARCHIVE PHOTOS

page 104

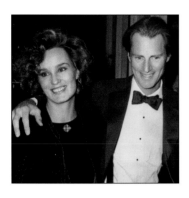 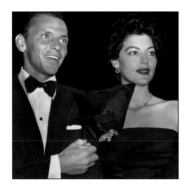 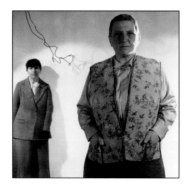 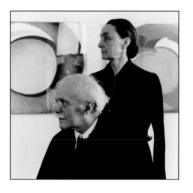

Sam Shepard &
Jessica Lange
are longtime companions.
Pulitzer-Prize winning play-
wright (*True West, Buried
Child*) and actor *(Country,
The Right Stuff)*, Shepard
and Academy Award winning
actress Lange *(Tootsie, A
Thousand Acres)* live on a
ranch in rural Minnesota.

John Connor
is a freelance writer living in
San Francisco.

Photo: UPI/CORBIS-BETTMANN

page 16

Frank Sinatra &
Ava Gardner
Sinatra—"The Chairman of
the Board"—and actress Ava
Gardner (*The Barefoot Con-
tessa* and *Night of the Iguana)*
were married in 1951. Despite
a tumultuous relationship, a
divorce, and numerous subse-
quent romances, they were
intertwined for the rest of
their lives.

Richard Jerome
is a regular contributor to
People magazine.

Photo: UPI/CORBIS-BETTMANN

page 48

Gertrude Stein &
Alice B. Toklas
were companions in Paris
during the 1920s and 1930s.
Stein is most acclaimed as
an art patron and author of
poetry, fiction, and essays.
Toklas published *The Alice
B. Toklas Cookbook* and was
the subject of Stein's famous
biography *The Autobiography
of Alice B. Toklas*.

Susan Schindehette
is a regular contributor to
People magazine.

Photo: CECIL BEATON

page 100

Alfred Stieglitz &
Georgia O'Keeffe
Stieglitz was a renown
photographer and curator
when he married the young
painter Georgia O'Keeffe.
O'Keeffe is known for her
flower paintings, New York
cityscapes, and her later
paintings inspired by New
Mexico, where she lived
after 1946.

Brenda Cullerton
writes regularly on artists
and photographers. Her
piece on O'Keeffe and
Stieglitz appeared in
Harper's Bazaar.

Photo: CECIL BEATON

page 90

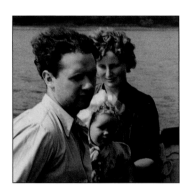 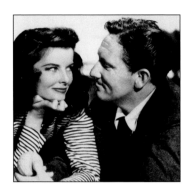 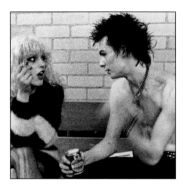 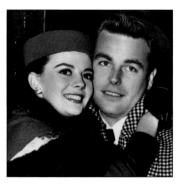

Dylan & Caitlin Thomas
The Welsh poet Dylan
Thomas married Caitlin
MacNamara in July 1937.
The following year they
moved to Laugharne, Wales
and Dylan released his
immortal *The Map of Love.*
Their first child, Llewelyn
Edouard Thomas, was born
in January 1939. They lived
together until Dylan died
on a lecture tour in America
in 1953, a few days after his
39th birthday.

Photo: POPPERFOTO/ARCHIVE

page 46

Spencer Tracy &
Katharine Hepburn
When Hepburn first met
Tracy, she barked: "I fear I
may be too tall for you, Mr.
Tracy." Apparently she
decided otherwise: over the
next 30 years, Hepburn (star
of *The Philadelphia Story*
and *Woman of the Year)* and
Tracy would star in nine
films and continue their leg-
endary clandestine affair.

Photo: SUPERSTOCK

page 86

Sid Vicious &
Nancy Spungen
At the zenith of their popu-
larity, the Sex Pistols' bass
player met the woman who
would change his life. The
couple's exciting, violent
affair was legendary in the
annals of punk rock and
came to a gruesome end in
the Chelsea hotel where
Nancy was found dead,
stabbed to death by Sid. A
few months later, Sid died of
an overdose.

J.D. Reed
is a staff writer for *People*
magazine.

Photo: DENNIS MORRIS

page 76

Robert Wagner &
Natalie Wood
were the toast of Hollywood
in the late 1950s. Wood was
known for her sexy film roles
in *Rebel Without a Cause,*
Splendor in the Grass, and
The Fine Young Cannibals
(with Wagner). She died
under mysterious circum-
stances in 1981. Wagner
became best known for his
work in television on shows
such as *It Takes a Thief,*
Switch, and *Hart to Hart.*

Edward Z. Epstein
has written numerous
biographies. His most recent
is *Born to Skate: The Michelle
Kwan Story.*

Photo: UPI/CORBIS-BETTMANN

page 54

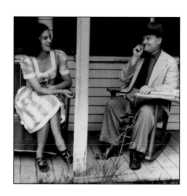

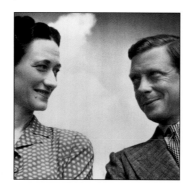

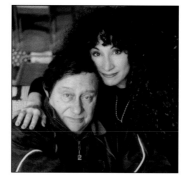

Edmund Wilson &
Mary McCarthy
wrote for publications such
as *The Nation, The New
Republic,* and *The National
Review.* Wilson made his
mark with volumes such as
Axel's Castle and *The Fifties,*
while McCarthy chronicled
American intellectual life in
fiction. They were married
from 1938–1946.

Carol Gelderman
is the author of *Mary
McCarthy: A Life.*

Photo: VASSAR COLLECTION

page 74

Duke & Duchess of Windsor
In 1930, while married to her
second husband, Bessie
Wallis met Edward, Prince
of Wales. Their relationship
became an international
cause célèbre and soon after
his accession, he abdicated
in order to marry her.
Shunned by most of the
British royal family, the
Windsors lived among the
international social elite,
mainly in France.

Walter Isaacson
is a writer for *Time*
magazine.

Photo: UPI/CORBIS-BETTMANN

page 42

Diane Ackerman &
Paul West,
partners of many years, are
both prolific authors. Acker-
man wrote the classics *A
Natural History of the Senses*
and *A Natural History of
Love* while West is author of
several novels, including *Life
with Swan.*

Photo: JILL KREMENTZ

introduction, page 10

credits